NURSING
THE FINEST ART

Master Prints

M. Patricia Donahue, Ph.D., R.N.

Associate Professor,
The University of Iowa College of Nursing,
Iowa City, Iowa

The C. V. Mosby Company

ST. LOUIS • BALTIMORE • TORONTO
1989

 Mosby

Editor: *Linda Duncan*
Assistant editor: *Joanna May*
Project editor: *Peggy Fagen*
Design: *John Rokusek*

Cover painting: The Sick Child, Gabriel Metsu, c. 1660,
Rijksmuseum, Amsterdam, Netherlands

Printed in the United States of America

The C.V. Mosby Company
11830 Westline Industrial Drive, St. Louis, Missouri 63146

VT/VH/VH 9 8 7 6 5 4 3 2 1

Preface

An overwhelmingly positive response to *Nursing: The Finest Art, An Illustrated History* by nurses and nonnurses alike prompted The C.V. Mosby Company to contemplate a smaller work, yet one that would again portray the art or esthetic aspects of nursing. The purpose of the proposed project, to be called *Nursing: The Finest Art, Master Prints,* would also be to portray the eloquent beauty of nursing and nursing care so that all who read the words and see the illustrations will appreciate its vitality. A primary difference, however, would be to provide the reader with the vital feeling or humanistic tone of nursing rather than focus substantially on its history. My task as the author was thus a formidable one as I struggled with a way to incorporate the elements of soul, mind, and imagination essential to the process of nursing, to incorporate the creative imagination, the sensitive spirit, and the intelligent understanding that provide the foundation for effective nursing care.

My first step was to consider what characterized nursing and why it was so important to me. There have certainly been days when I have questioned my choice of a career—days when I have asked myself why I ever wanted to become a nurse. As I pondered that question I heard a familiar tune booming from the television set: "Be all that you can be, Find your future, In the Army!" Wouldn't it be grand, I thought, if nursing had a catchy but tasteful tune with a well-known slogan that people would recite over and over again in their heads: "Be all that you can be, Join nursing!" I then began to reflect on a discussion I had had many years ago with my father who, because he believed that I could do anything I set my mind to do, questioned my decision to become a nurse. "Why do you want to become a nurse?" he said, "You can be a concert pianist, a lawyer, a doctor . . ." Then he paused and asked, "What is the reward?" I am sure that other nurses have been so queried and have felt at a loss as to what to answer.

I began to generate a "list" of rewards, some of the *real* rewards of nursing:

The look of incredible joy on the faces of new parents as you place the newborn baby in their arms;

The feel of a child's arms around your neck as he hugs you tightly, knowing and trusting that you will protect him;

The touch of a patient's fingers on your cheek when the patient cannot verbally communicate but wishes to say "Thank you";

The closeness that you share with a family of a terminally ill patient;

Eyes that light up in recognition of your presence;

The peace and contentment that are experienced as you sit and hold the hand of one who is dying;

The knowledge that you have truly cared "for" and "about" another individual;

The satisfaction of assisting an individual to achieve under the bleakest of circumstances; and

The smile of a patient when he is told that he does not have cancer.

These are the rewards of nursing that are so intangible and almost indescribable. These are the rewards that we must learn to articulate. In truth, no one had ever adequately prepared me for the wonders of nursing: the emotional ups and downs; the physical dimensions that demand strength and exertion that may be stretched to the very limits of one's being; the spiritual element that can tax one's faith, can shake it to its very foundation; the observation of miracles; and the growth and development that occur beyond one's wildest imagination. In the final analysis, nursing puts us in touch with being human. Thus, the direction for nursing must be in the area of holistic, humanistic interrelationships in which the values of individual human dignity, quality caring, and humanitarian concern are emphasized.

It is sincerely hoped that this book will provide some insight into that which is truly nursing, into that which is truly a nurse. Specific words were chosen to exemplify those attributes or characteristics that are consistently exhibited by nurses in their practice. They represent a mere fraction of the words or concepts that serve to portray the inherent qualities of nurses. The artwork coupled with the text is an attempt to articulate meaning in a manner that mere words cannot as well as to provide a visual presentation.

Many individuals have been involved with this project in different ways. To all of them I extend my sincere appreciation. They know of their invaluable assistance and unique contributions.

M. Patricia Donahue
Coralville, Iowa
August, 1988

Contents

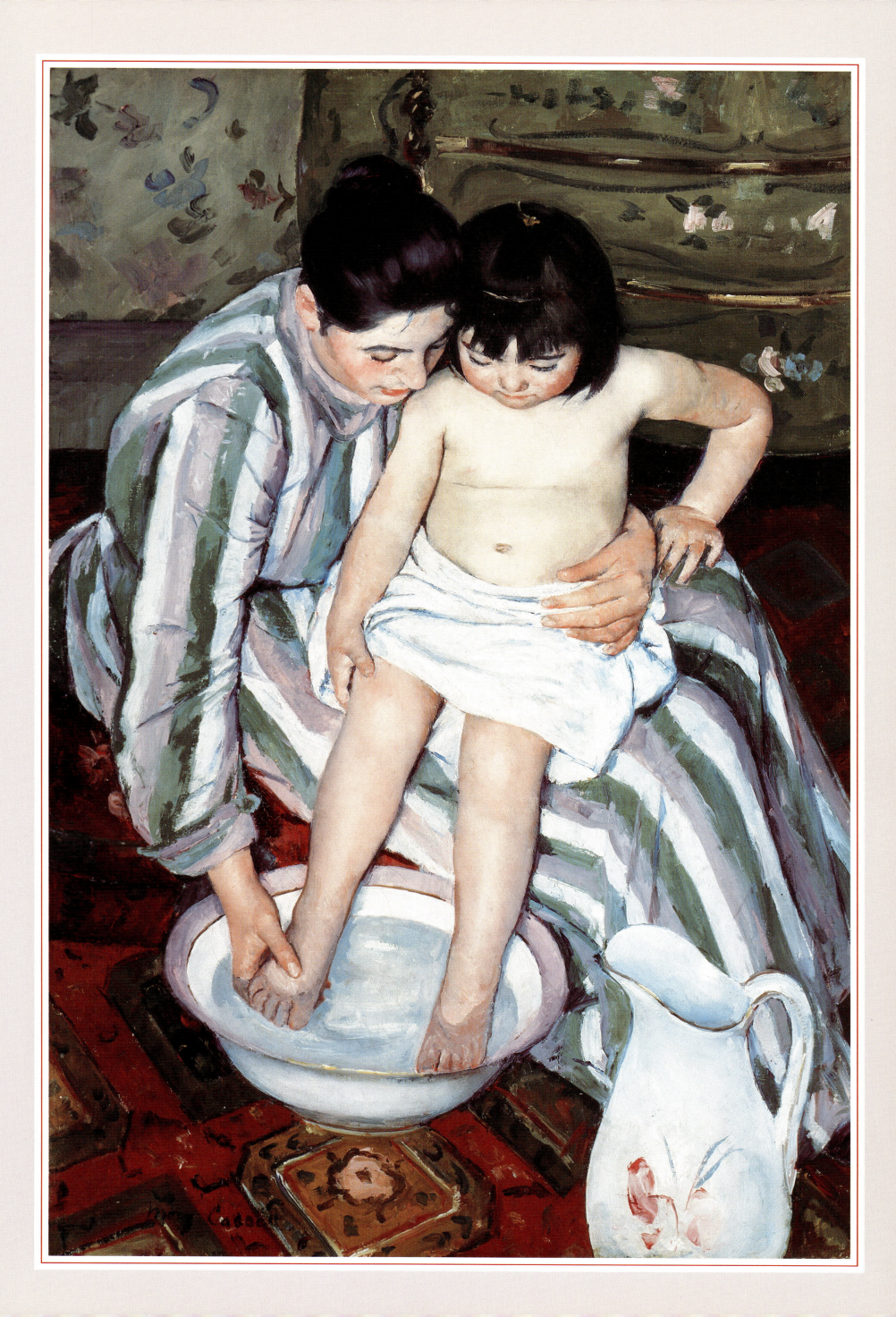

THE BATH

Mary Cassatt
c. 1891

Canvas, 99.1 × 66 cm
Courtesy of the Art Institute of Chicago, Illinois
Robert A. Waller Fund

TENDERNESS the careful and sensitive handling of patients that contributes to the image of nursing as an art. Tenderness has long been recognized by nurses as important in communication with patients. It serves to convey softness and gentleness, those qualities deemed necessary by patients and family members to convey a sense of genuine caring. As the development and use of technology in health care have escalated to astounding proportions, it has become even more important for nurses to promote the humanistic aspects of care, those aspects that impart the awareness of the patient as a human being. Nurses must continue to be innovative and creative in approaches to patient care, must continue to develop roles that will improve that standard of care. This is not a new idea but one that has been evident throughout time. The profession of nurse-midwifery arose out of such concern for the well-being of mothers and babies. Infant and maternal death rates had become a serious problem and were attributable to many causes, including poor or no prenatal care, poor nutrition from ignorance and poverty, and infectious disease in early pregnancy. In some instances delivery at the hands of ignorant and filthy midwives contributed to mortality. The training of nurses in midwifery in the United States had been prevented primarily by the attitudes of physicians. However, studies were undertaken that began the long march to reform as some nurses began to advocate the training and use of nurse-midwives, particularly in those areas where medical care was lacking. A few schools for nurse-midwives were eventually developed. The Frontier Nursing Service, founded in 1925 by Mary Breckinridge, provided the first organized midwifery service in America in the hills of Kentucky. Here nurses demonstrated the usefulness of such a service in areas where physicians were not readily accessible.

PLATE 1

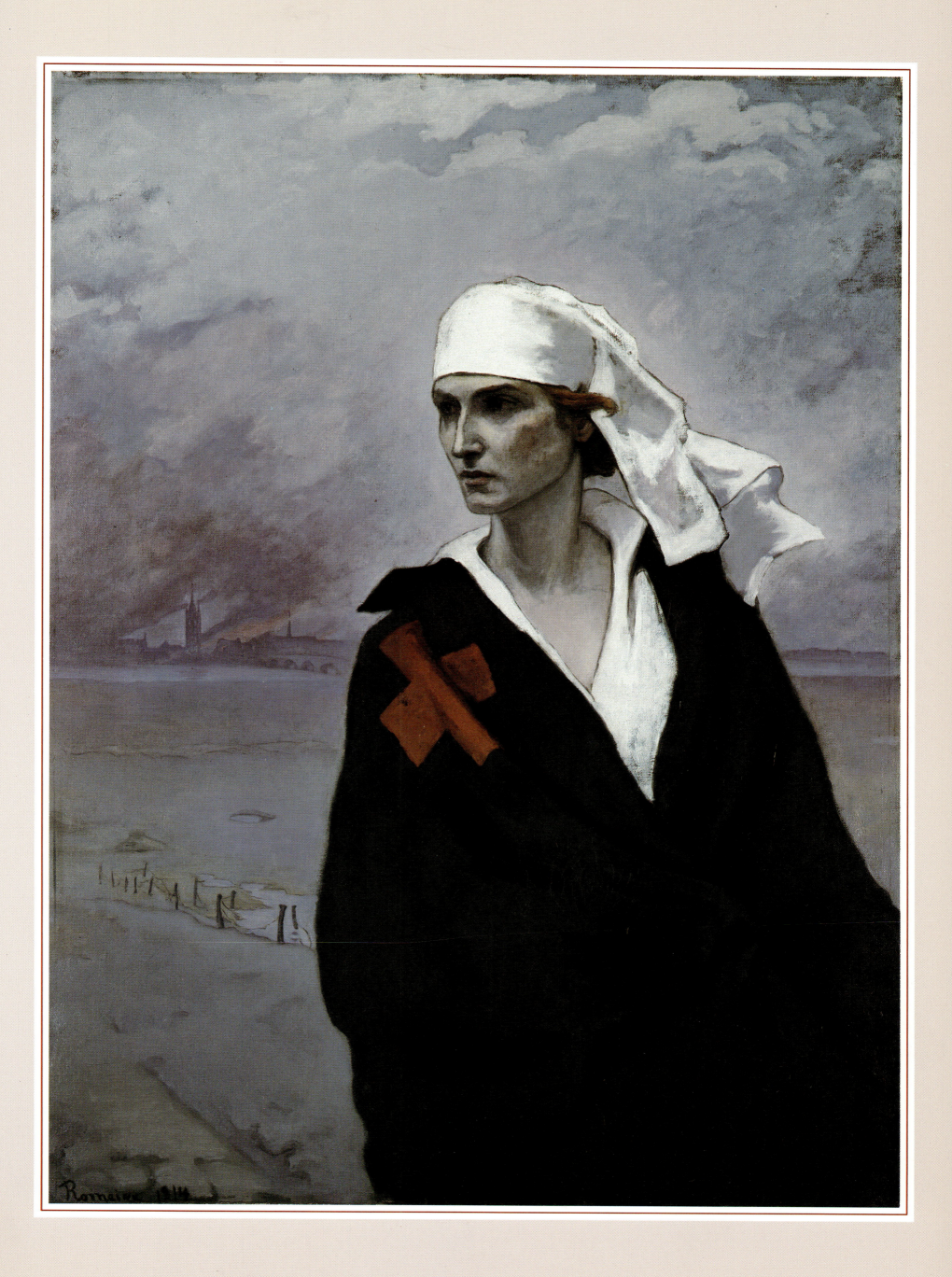

LA FRANCE CROISÉE (The Cross of France)

Romaine Brooks
1914

Canvas, 116.2 × 85 cm
National Museum of American Art
Smithsonian Institution, Washington, D.C.
Gift of the artist

HUMANITARIANISM a philosophy that asserts the worth and dignity of the individual; a philosophy that guides nursing in its caring functions. Humanitarianism has long been a motive for rendering nursing care. This interrelationship is frequently demonstrated by nursing's involvement with agencies such as the Red Cross. A great humanitarian, J. Henri Dunant, was instrumental in setting up this international organization that would provide volunteer nursing aid on battlefields. The stimulus for this development was his journey to Italy to secure a meeting with Napoleon III of France. At Solferineo he was witness to the horrors of the bloodiest battle of the war between France and Austria. Depressed by the lack of medical services, Dunant enlisted local people to give whatever aid and nursing care were possible. His subsequent appeal to various European governments finally culminated in the International Red Cross, an organization committed to humanitarian services. Dunant repeatedly referred to Florence Nightingale and her work in the Crimea as the inspiration behind his crucial trip to Italy. Her work had also fortified his belief in the feasibility of such an organization. Each government agreed to honor Red Cross nurses as noncombatants and to respect their hospitals and other facilities. In addition, societies in neutral countries would be permitted to render services to either side. Nurses have consistently occupied a place of honor as they have carried out the humanitarian mission of the Red Cross during time of peace and time of war.

PLATE 2

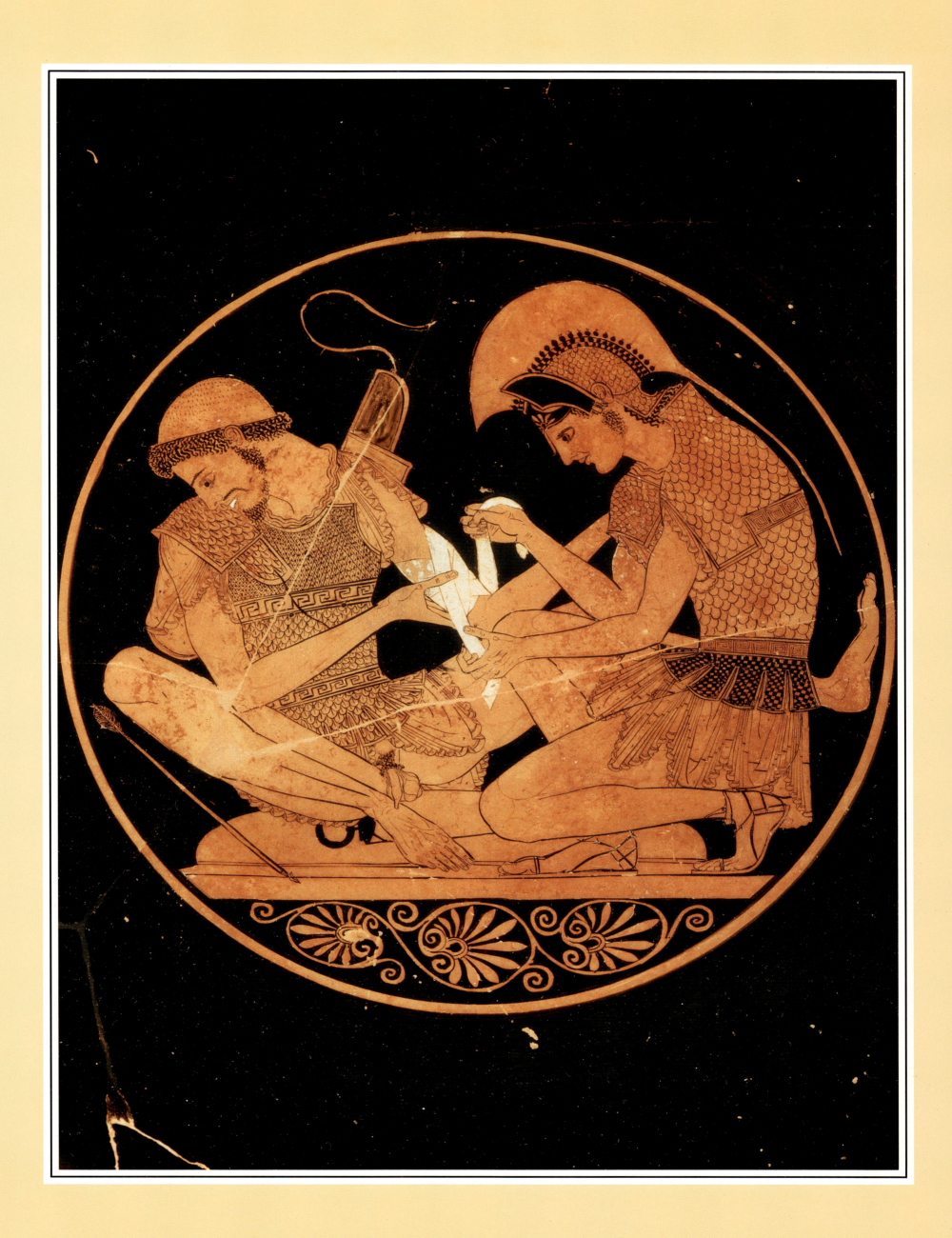

ACHILLES BANDAGING THE WOUNDS OF PATROCLUS

Detail from the bowl of Sosias
c. 50 BC

Museum of Greek and Roman Antiquities
Staatliche Museen Preussischer Kulturbesitz
Berlin, Federal Republic of Germany

SKILL the ability not only to use one's knowledge effectively but also to competently execute learned physical tasks inherent to one's occupation. Early in nursing's progression, it became apparent that love and caring alone were not sufficient to nurture health or overcome disease. The development of nursing depended on two additional essential ingredients—skill, or expertness, and knowledge. Great manual dexterity in the carrying out of specific procedures was evident even among primitive tribes and in ancient civilizations and continued to be perfected through experience. As more and more information about illness and disease became available, emphasis on the necessity of knowledge and its interrelationship with skill began to emerge. Knowledge of facts and principles as the basis for action would ultimately provide the initiating force for nursing to become both an art and a science. Skill in nursing has come a long way since the time of the ancient civilizations, in which mythologies and religions were founded on the basic principle of nature worship, belief in evil spirits as causes of disease progressed to a belief that disease was caused by a failure to do things that the gods wished or by some moral transgression, legends and myths of deities who watched over health and had powers over life and death were composed and cultivated, and traditions of worship and methods for requesting divine aid for the sick were established. The cultural patterns in these early centers of civilization thus exhibited an interdependence of religion, government, social welfare, and health. Indeed, the beliefs, mores, and culture of each civilization directly influenced the way in which nursing care was given and the skills necessary to provide such care. Who rendered nursing care and what constituted nursing care were reflections of the prevailing society.

PLATE 3

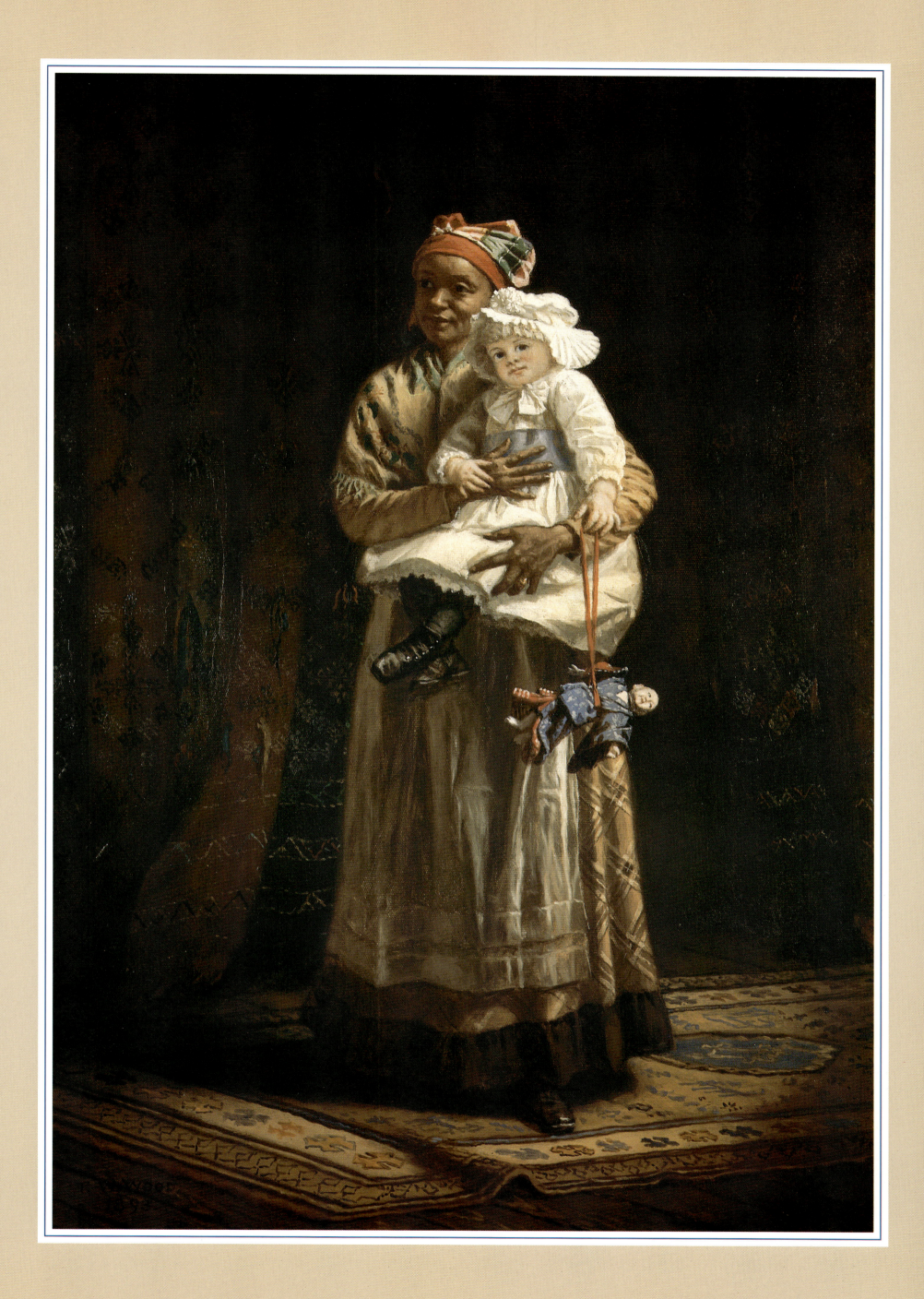

THE FAITHFUL NURSE

Thomas Waterman Wood
1893

Oil on canvas, 28 × 20 inches
Wood Art Gallery
Montpelier, Vermont

FAITHFULNESS firmness in adherence to promises or in observance of duty. Faithfulness implies loyalty, conscientiousness, steadfastness, and allegiance. The majority of nurses will readily state their belief that their faithfulness or allegiance is first and foremost to the patients they serve. They will, however, describe their frustration as they are torn by loyalty not only to the patient but also to their educational and employing institutions and physicians. Since nurses in most instances do not have direct access to patients, they are frequently caught in powerless situations in which they must sometimes compromise their beliefs and values. A minority group of nurses, however, have dealt admirably with impediments from both society and nursing itself. Blacks have been typically shown as slaves, nursemaids, and "nannies" who are ever faithful to their charges. They have worked constantly for the acceptance of Blacks in nursing, for the promotion of equal opportunities to minority persons in nursing. Unfortunately, separate schools for educating Black nurses arose in America, a necessity in order that Blacks, who were banned from many schools, could receive training in nursing. These schools experienced difficulties similar to those of the early white schools but also suffered from societal prejudice toward Blacks. Although the nursing organizations never expressed any racial prejudice, Black nurses were denied membership in some state and local nursing organizations. Thus, to break down discriminatory practices that occurred because of the hue of their skin and with no consideration for their nursing proficiency, they established a separate organization, the National Association of Colored Graduate Nurses (1908). Numerous Black nurses have emerged as significant nursing leaders, made valuable contributions to nursing, and brought the concerns of Blacks in America to the attention of both nurses and the general public.

PLATE 4

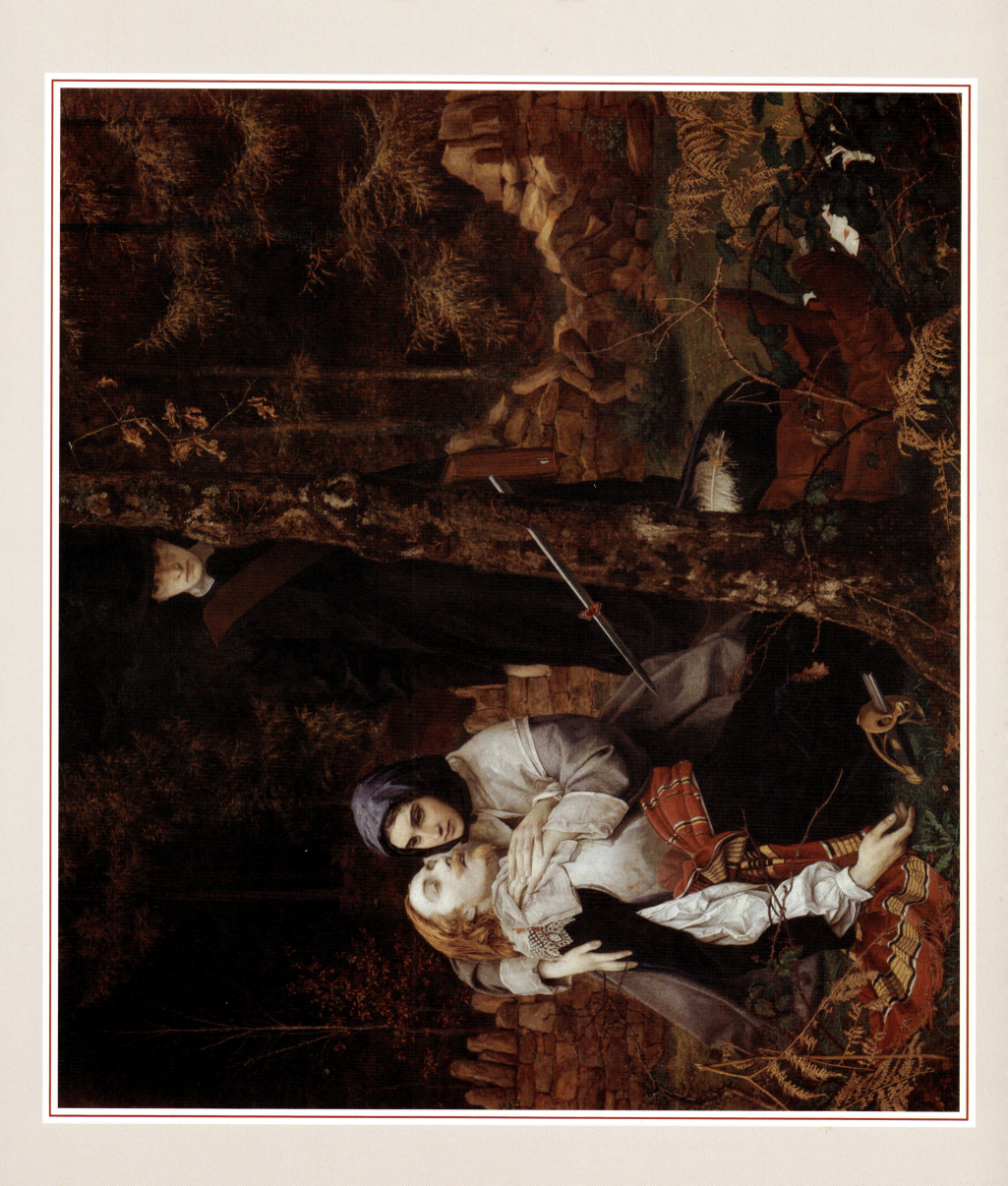

THE WOUNDED CAVALIER

William Shakespeare Burton
c. 1856

The Bridgeman Art Library, Guildhall Art Gallery
City of London, England

STRENGTH a personal attribute that nurses frequently share with or foster in those to whom they render care. Strength implies the capacity for endurance that can be viewed from both a psychological and a physical standpoint. Nurses must be personally strong but also nurture strength in patients who are faced with some of the most devastating disease states, who are faced with their own mortality, who are extremely vulnerable. Nurses must be personally strong as they function in times of peace and war, as they struggle to provide safe and quality care in less-than-desirable situations, as they must reassure significant others when chances for recovery are slim. Strength thus is an asset demonstrated in all nursing circumstances but most prominently recognized and respected during time of war. For it has often been said that nursing has made its greatest advances and most notable achievements in connection with wars. In general, this statement is probably true, particularly when viewed from a historical perspective. One might wonder, however, why this has been the case, since injury and illness have always existed side by side with humanity. It seems that the truth of the statement lies in the fact that nations tend to recognize, respect, and value nurses when faced with the human tragedies of war. The unique circumstances of the war and the need for care of the wounded dramatically emphasize the value of nurses. Nurses are thus raised to a position of national stature. But as the the nation once again settles into calm at war's end, the value and stature of nurses rapidly become a thing of the past.

PLATE 5

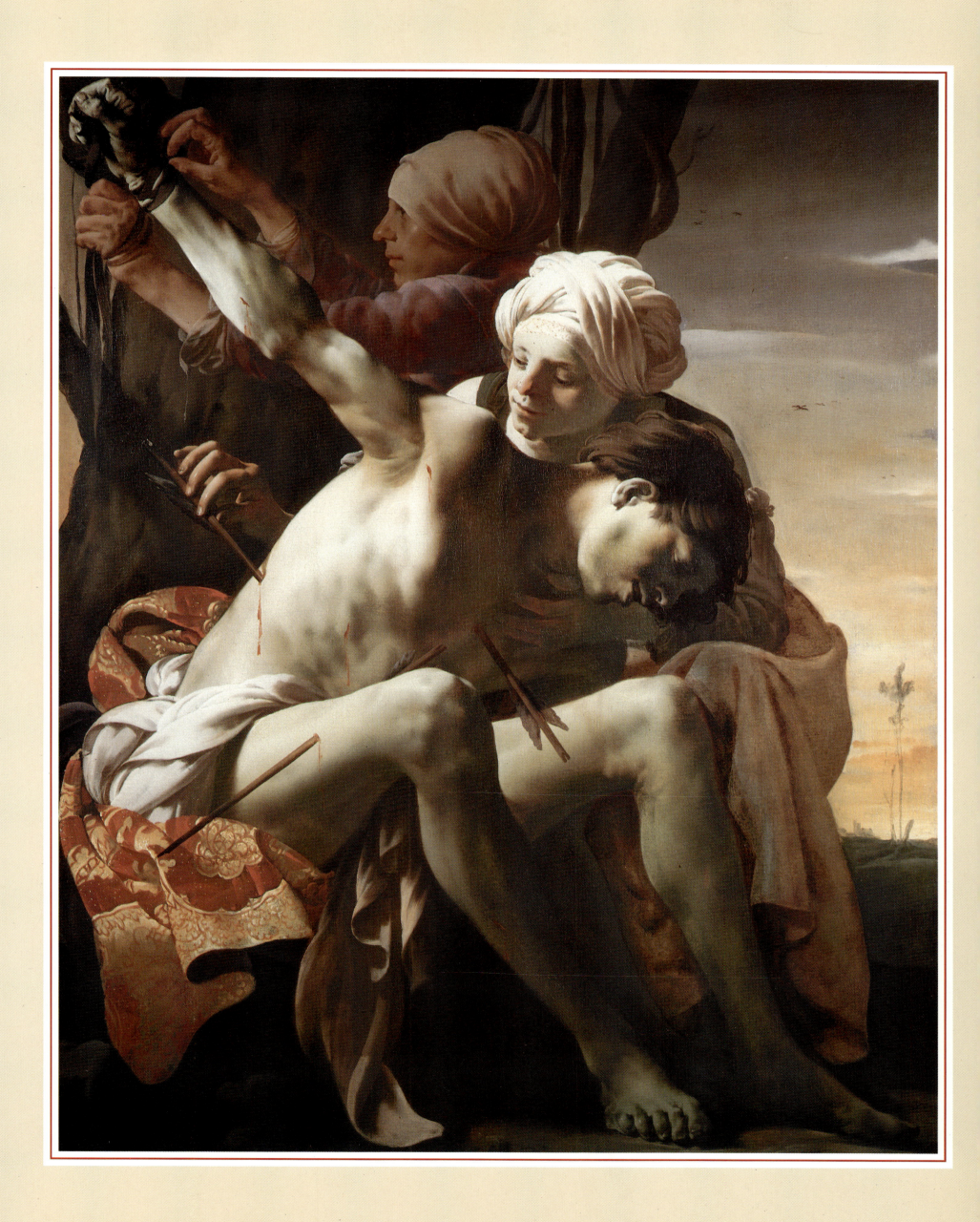

ST. SEBASTIAN ATTENDED BY ST. IRENE

Hendrick Terbrugghen
c. 1625

Canvas
Allen Memorial Art Museum, Oberlin, Ohio

LOVE unselfish love that became the spiritual motivation embraced by those who chose to devote themselves to the welfare of others. With the beginning of Christianity the history of nursing emerges as an unbroken pattern. Pre-Christian records are fragmentary and scattered; however, records of nursing from the days of the early Christian workers to the present are continuous. The first five centuries of the Christian era witnessed the rise of a religious and social movement that enabled the systematic development of organized nursing. This marvelous activity of love and mercy was embraced by many men and women who responded to the teachings of Christ. Consequently, Christ's teachings of love and brotherhood transformed not only society at large but also the whole of nursing. "Organized nursing" was a direct response to these teachings and epitomized the concept of pure altruism initiated by the early Christians. Some of these Christian men and women who cared for the sick became known as nursing saints. Many people benefited from their services, including St. Sebastian. The public declaration of his faith in Christianity and his affiliation with the Church resulted in his being fastened to a stake and shot by arrows. Later that night, St. Irene found him still alive. With the help of other holy women, she nursed him back to health. Their care has been documented and portrayed through the years by many artists. As a result, St. Sebastian became a popular subject of medieval art. The idea that contagious or infectious diseases were shot into the body by invisible arrows fostered the practice of praying to St. Sebastian for prevention or cure.

PLATE 6

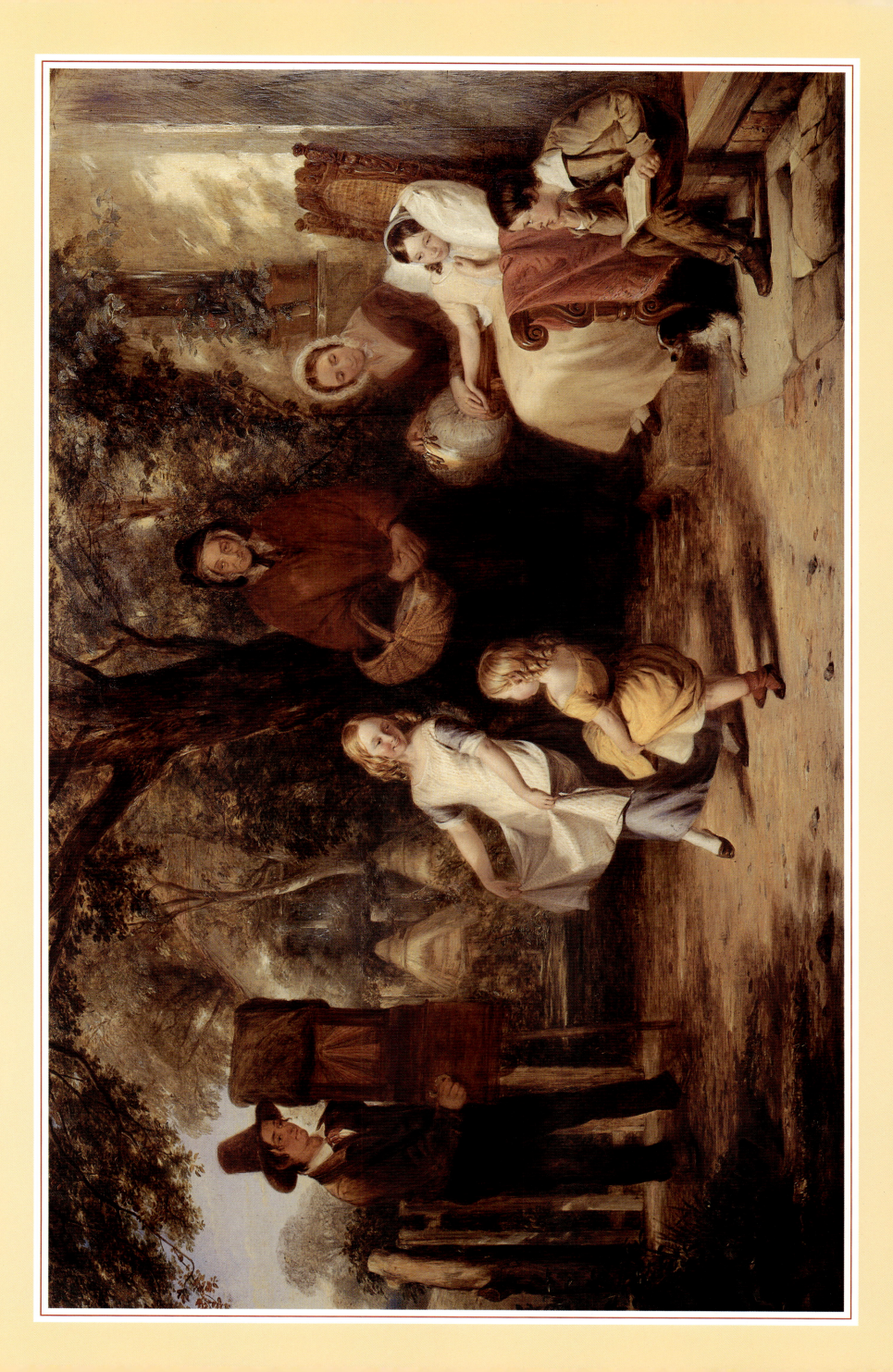

SICKNESS AND HEALTH

Thomas Webster
1843

The Bridgeman Art Library Ltd./Victoria and Albert Museum
London, England

CARE AND CARING the most valuable aspects of nursing. Caring is the essence of nursing—caring for, caring with, and caring about. No one, however, through pen or canvas, will ever be able to entirely capture the true art and the caring spirit of nursing. Both defy expression! Caring is concrete yet abstract, a simple yet complex term. It is simple because it is a word that most people believe they understand; it is complex because caring in nursing encompasses the totality of the human being: the body, the mind, and the spirit. Nursing care involves attention to all facets of the human being including the physicial, biological, cultural, social, psychological, spiritual, and economic. It mandates a consideration of and provision for a holistic approach with patients. It mandates provision for attention to individuals during times of sickness as well as during times of health. The prevention of sickness and the maintenance of health have thus always been a vital part of the nursing art. The heritage of nursing is a rich one. Its history is a record of pioneering that reflects new advancements with each generation. Its history is a record of caring, caring that has of necessity meant different things at different points in history and resulted in a variety of practices initiated by a variety of motives. The study of nursing history clearly indicates that the direction for nursing must be in the area of holistic, humanistic interrelationships; that nurses should and must take a leading role in emphasizing the values of individual human dignity, quality caring, and humanitarian concern. Whatever the circumstances, nurses always can "care," whether or not the patient can be "cured."

PLATE 7

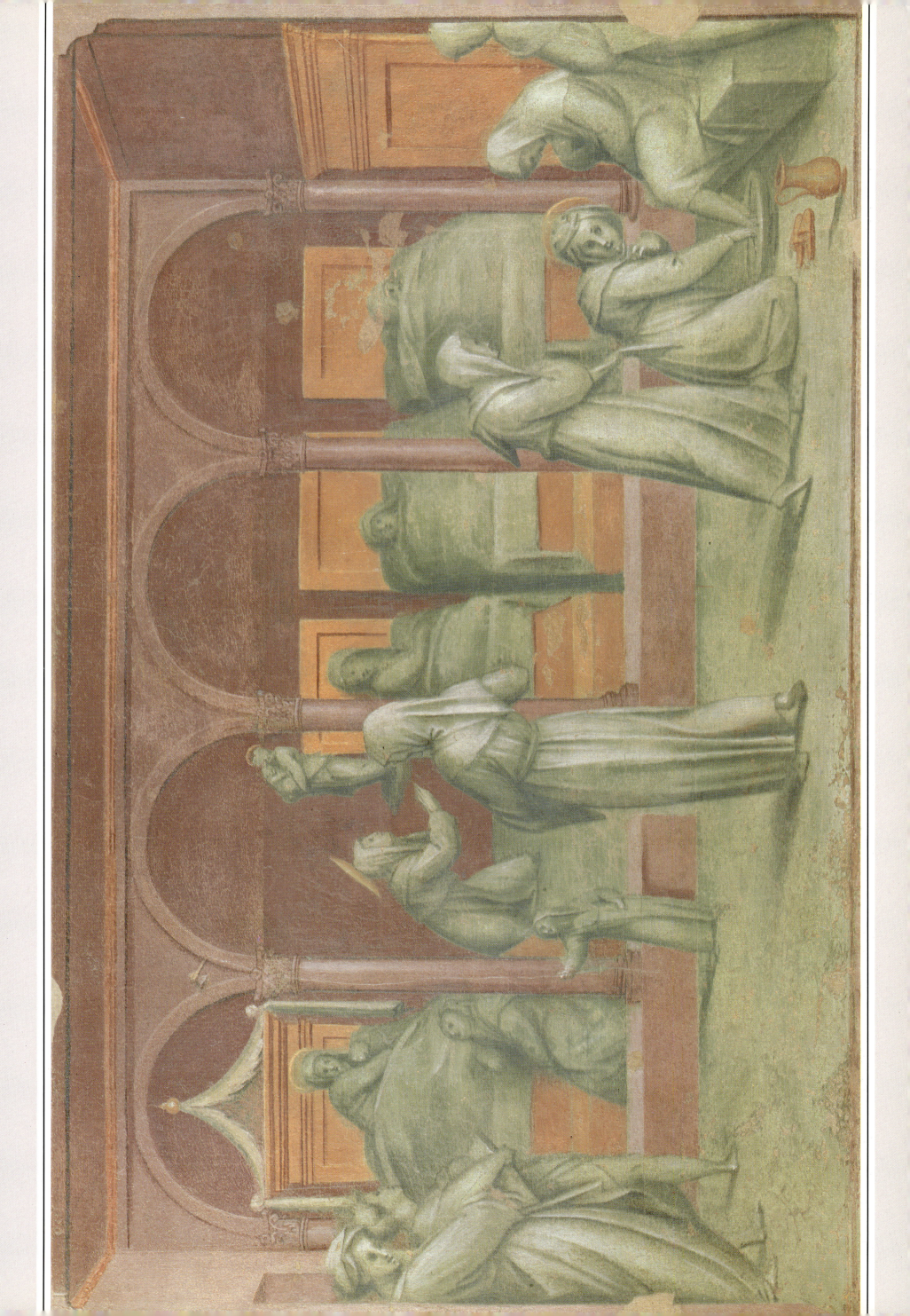

HOSPITAL SCENE

Pontormo
Early sixteenth century

Accademia, Florence, Italy (SCALA/Art Resource, New York)

CHARITY the benevolent goodwill or love of humanity that became closely aligned with nursing with the advent of Christianity. This benevolence was also important in the development and construction of early Christian hospitals begun through the charity of individual women. As the Catholic Church became freely established, bishops assumed responsibility for the expansion of charitable facilities as well as responsibility for the care of the sick. Thus houses for the sick, for strangers, for the poor, and for the aged existed in the fourth century and were indicative of the Christian expectation that all who needed help would receive it. These were ancestors of the modern hospital as well as of most other types of charitable institutions. The development of hospitals in European cities continued during the late Middle Ages. The idea of city hospitals also began to meet with support and approval, and in some cases hospitals passed amicably from ecclesiastical to secular control. Several factors contributed to the demand for more hospitals: existing hospitals had been organized as orphanages, hospices for travelers and the sick, and almshouses; communicable disease was uncontrolled; urban life had been hastily developed; and crowded living conditions were contributing to the spread of disease. In general, the hospitals were erected to care for the sick poor. The wards were very large; privacy was frequently provided by the use of cubicles. The structures were usually beautiful, having been constructed at a time when every public building was to be a work of art. Medieval hospitals were a place to keep, not cure, the patients. The aspect of cure evolved slowly and did not become widespread until the late nineteenth century. Nursing care, largely custodial in nature, was done primarily by monks and nuns, although servants were used part of the time.

PLATE 8

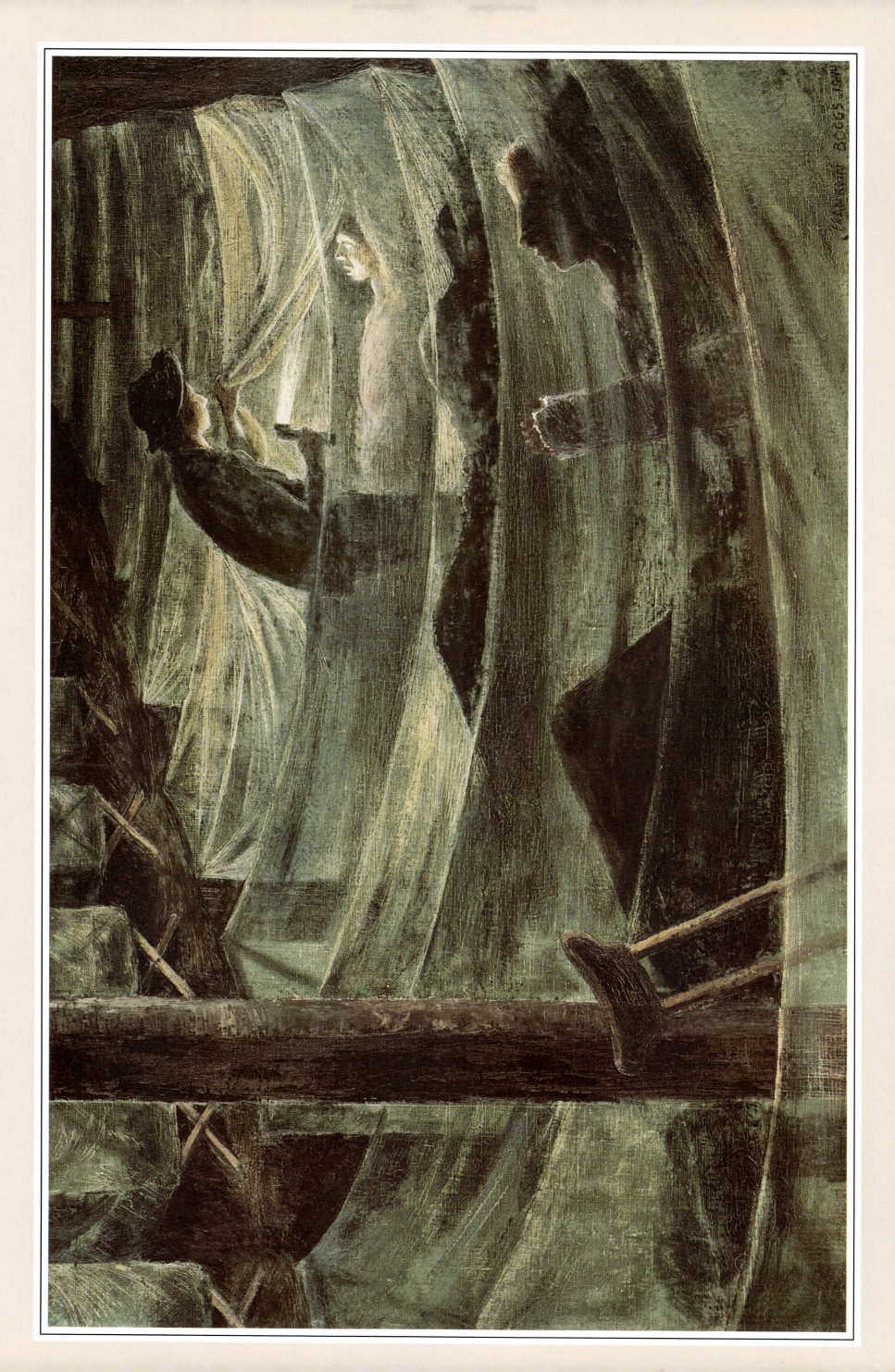

NIGHT DUTY

Franklin Boggs
1944

U.S. Army Art Collection

SPIRIT the essence of a being that is so difficult to define. The "spirit of nursing" has long been described as a special attitude or frame of mind, that vital principle that gives life to the discipline of nursing. It encompasses the tenderness, compassion, competence, courage, and human qualities of the nurse. This spirit is exhibited in all that nurses do and has been especially referred to in conjunction with nursing's involvement in wars. It was, however, the Second World War that brought the American nurse to national stature. By World War II, nurses constituted an integral part of the military structure. They were accustomed to organization, had a working knowledge of war that had been gained through personal experiences, and were prepared to meet the demands of modern warfare. By the end of this war, the romance between the nurse and the American G.I. would be real, built on mutual admiration and respect. The bravery of the nurses under the most rigorous and demanding situations was witnessed by many soldiers, who wrote of these experiences. The global scope of the war presented a sharp challenge to military nurses. By the end of the war, nurses had been stationed on the soil of approximately fifty nations scattered over the face of the globe. They worked and lived in the installations of the Army and the Navy, in hotels and other adapted structures, in cantonment barracks, in tent hospitals, and in quonset and other prefabricated huts. Speed in rendering care was probably the biggest factor that kept the death rate below that of World War I. Nursing care contributed to this decreased mortality and made a great difference in the recovery of sick and wounded soldiers. The Nurses' Monument in Arlington National Cemetery symbolizes the "Spirit of Nursing" of the past, the present, and the future.

PLATE 9

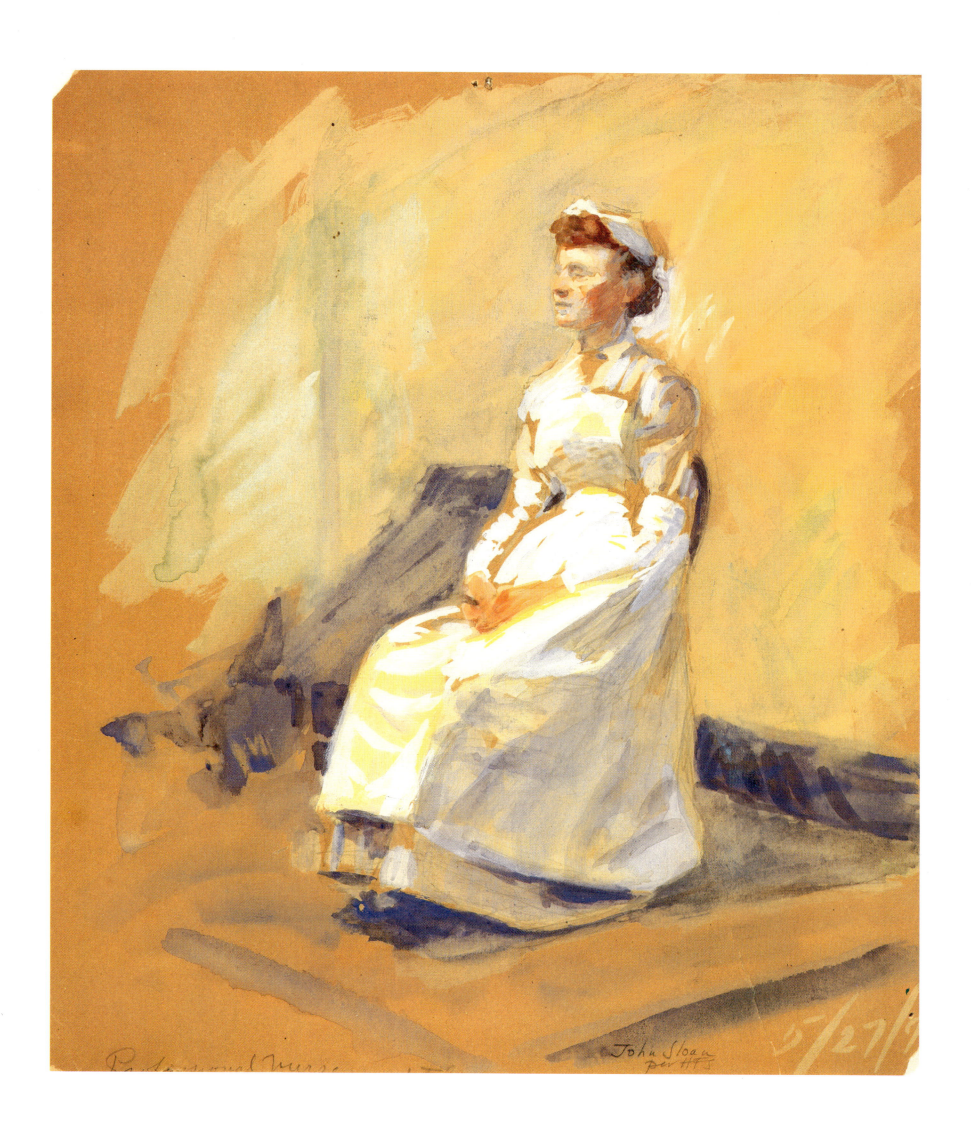

Professional Nurse John Sloan 5/27/?
 per AFS

PROFESSIONAL NURSE

1893

Watercolor, 10¾ × 9 inches
The Delaware Art Museum, Wilmington, Delaware
The John Sloan Collection

EXCELLENCE the ultimate goal for which nursing constantly strives in its mission of service to humanity. Excellence in practice is not a new challenge to nurses and nursing. From its earliest beginnings, the profession has continually endeavored to excel in patient care but has also grown and developed into a discipline that studies, researches, and creates new knowledge. As the end of the twentieth century approaches, nursing stands poised between the past and the future. The question of what lies ahead is open to speculation, as the state of nursing's art is ever changing and responsive to societal needs. This century has been marked by many changes in the healing arts, some of which are in striking contrast to earlier epochs in history. Yet many of the extraordinary innovations that have occurred are continuations of contributions from the past. These changes have resulted from an interplay of numerous factors that have arisen in an increasingly technological age. There is little doubt that nursing practice has been forced to make severe accommodations within this larger societal context with increased knowledge and shifting attitudes and values. Nurses of today are expected to be many things to many people and to function in a variety of settings. They are to be excellent caregivers, adequate researchers, seekers of knowledge, and thinkers grounded in scientific and logical thought. Nurses are involved with scientific and technical advances and with all types of new roles that have broadened their opportunities but increased the scope of their responsibilities. They are slowly but steadily moving toward a goal of holistic and excellent treatment for *all* individuals in a structure that is not always supportive.

PLATE 10

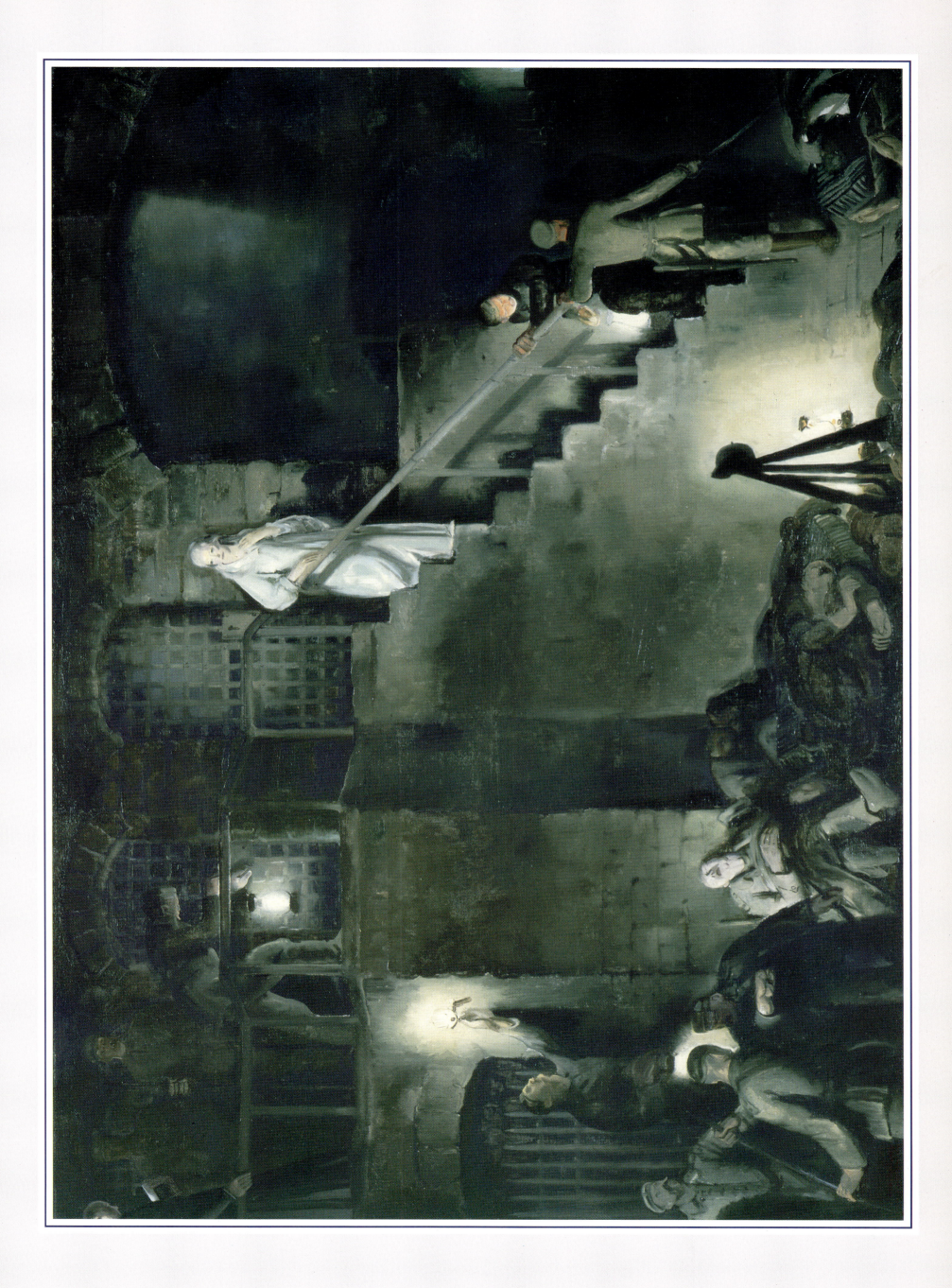

**EDITH CAVELL DIRECTING THE ESCAPE OF SOLDIERS
FROM PRISON CAMP**

George W. Bellows
1918

Oil on canvas, 45 × 63 inches
Museum of Fine Arts, Springfield, Massachusetts
The James Philip Gray Collection

DEDICATION the self-sacrificing way of life exhibited by many nurses. This dedication is a serious commitment to the cause, ideal, and purpose of caring for humanity. Edith Cavell (1865-1915), an English nurse, was a vivid example of such dedication, which culminated in the loss of her own life. She had organized the first school for nurses in Brussels, Belgium in 1909. When World War I began, she remained at the school, where she cared for soldiers of all armies and directed the escape of Allied soldiers from prison camps. Although she had also faithfully cared for German soldiers, diplomatic efforts to obtain her reprieve were unsuccessful. Miss Cavell could have escaped but remained at her post until she was arrested and charged with harboring British and French soldiers and assisting them to escape from Belgium. She did not deny the charges and faced her execution before a German firing squad on October 12, 1915 with tremendous courage. Her unwavering dedication exemplified a strong religious spirit and provides a role model consistent with a belief in one's convictions. Her last words convey strength and dignity: "I have no fear or shrinking. I have seen death so often that it is not strange or fearful to me. I thank God for this ten weeks' quiet before the end. Life has always been hurried and full of difficulty. This time of rest has been a great mercy. They have all been very kind to me here. But this I would say, standing as I do in view of God and eternity: I realize that patriotism is not enough. I must have no hatred or bitterness towards anyone."

PLATE 11

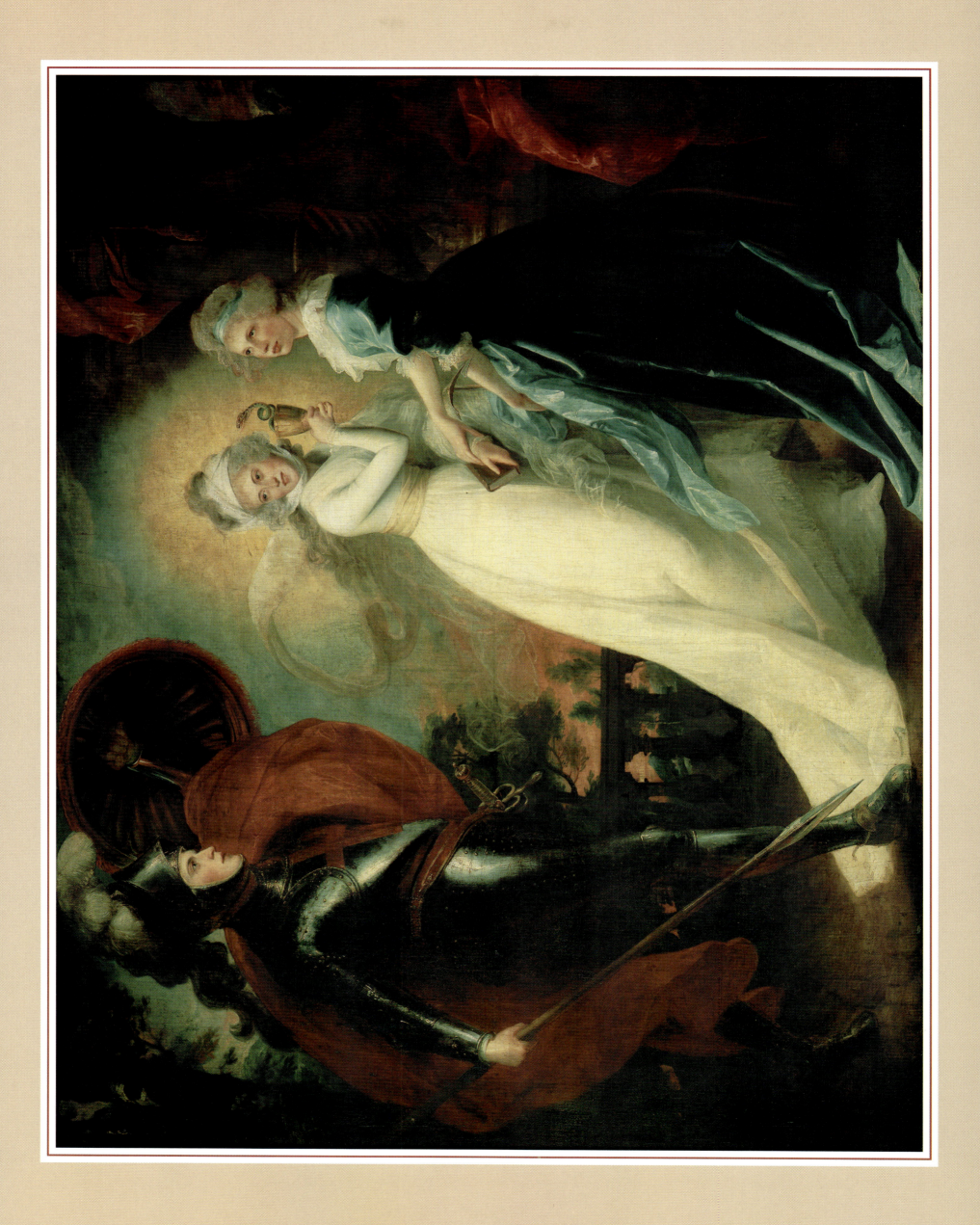

THE RED CROSS KNIGHT

John Singleton Copley
1793

Canvas, 213.5 × 273 cm
National Gallery of Art, Washington, D.C.
Gift of Mrs. Gordon Dexter

DISCIPLINE the system of rules that has governed the conduct, mental faculties, and moral character of nurses for many years. Numerous interacting forces were activated in the period known as the late Middle Ages. As a result of these forces, a resurgence in religious fervor demonstrated itself in reforms of the monasteries and priesthood, Crusades against the heretics of the Near East, and an increase in pilgrimages to the Holy Land. Nursing was affected by these events because crowded living conditions and the resulting increase in the spread of disease created a need for the establishment of new and different types of orders to care for the sick. Great numbers of men became members of military nursing orders, and the military ideal of discipline and order entered nursing. Emphasis was now placed on rank, deference to superior officers, and the vow of unquestioning obedience. All of these profoundly affected the progress of nursing and nursing education for many years to come. These great military nursing orders were called by the name of "Knights Hospitallers." They combined the attributes of religion and chivalry, as well as militarism and charity, in their dedicated services. The knights were men of patrician birth who bore arms, protected pilgrims, and fought in the Crusades. When they were not engaged in battle, they helped to nurse the sick and the wounded and established great hospitals. Three of these orders stand out as the most famous and most important in history: the Knights Hospitallers of St. John of Jerusalem, the Teutonic Knights, and the Knights of St. Lazarus. Frequent references are also made to Red Cross Knights, although this group was always purely military.

PLATE 12

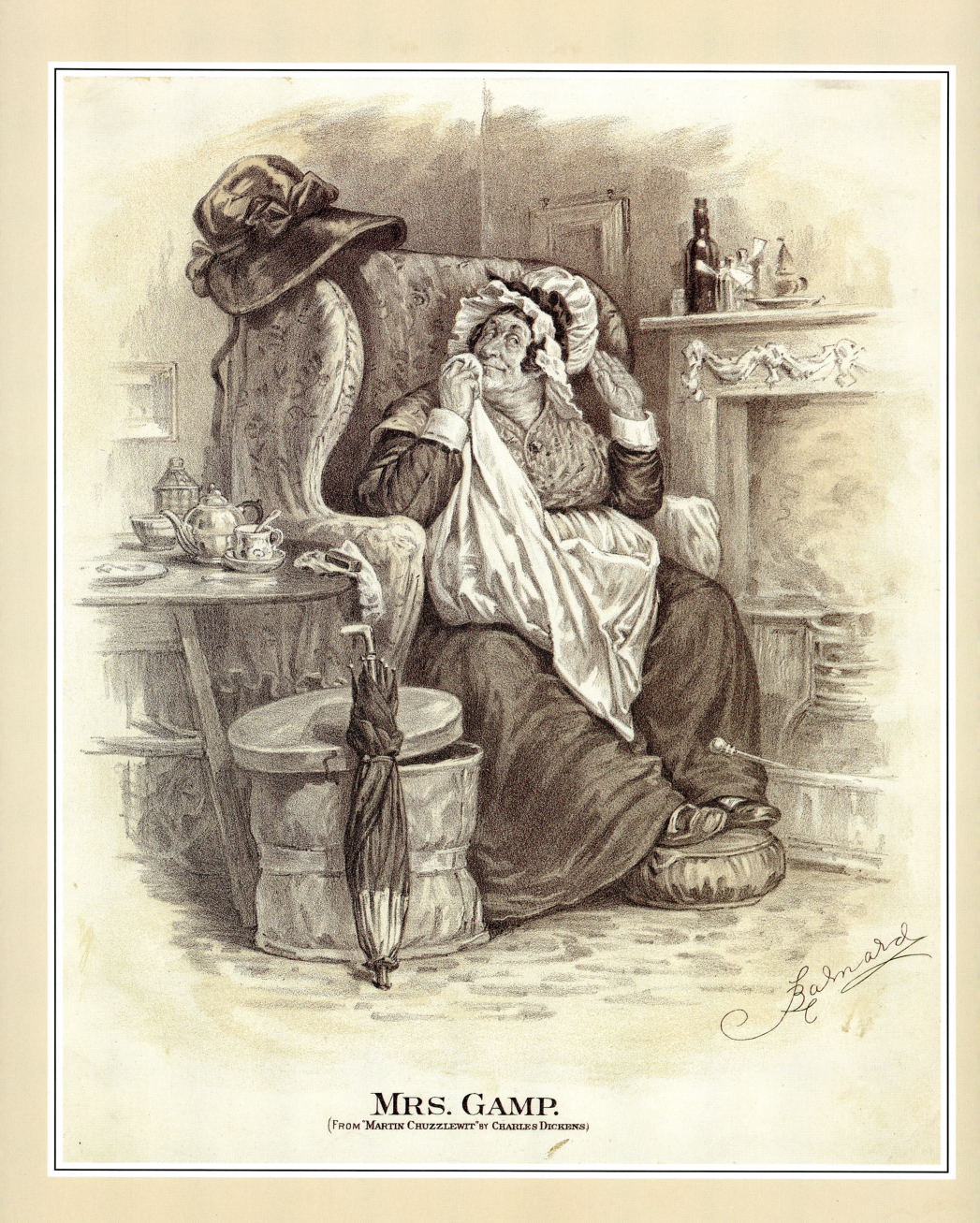

MRS. GAMP.

(From "Martin Chuzzlewit" by Charles Dickens)

TOLERANCE the ability to endure and grow even when faced with difficult or unfavorable conditions. Nurses exhibit tolerance in a variety of circumstances such as when confronted with differing beliefs, values, races, and creeds, confronted with almost insurmountable hardships, and subjected to negative stereotypes and/or images. The image of nursing has changed over the centuries in concert with social reality. Yet tolerance for less-than-desirable nurse images, even if accurate, can be difficult, as in the case of the classic Mrs. Sairey Gamp. The latter half of the period between 1500 and 1860 saw nursing conditions at their worst. In general, the lay attendants or nurses were illiterate, rough, and inconsiderate, oftentimes immoral and alcoholic. They were drawn from among discharged patients, prisoners, and the lowest strata of society. They scrubbed, washed, cleaned, worked long hours, and essentially led a life of drudgery. Pay for nurses was poor and was frequently supplemented in any way possible, as with bribes. There was little organization associated with nursing and certainly no social standing. No one would enter nursing who could possibly earn a living in some other way. An examination of nursing was conducted by Charles Dickens, whose descriptions of nurses were effective caricatures. He depicted nursing conditions through the immortal characters of Sairey Gamp and Betsy Prig. Mrs. Gamp represented the hired attendant for the sick, the private duty nurse; Mrs. Prig portrayed the hospital nurse. Help was needed, and the prevailing nursing situation and public concern eventually resulted in the beginning of significant changes that directed steady reform in nursing.

PLATE 13

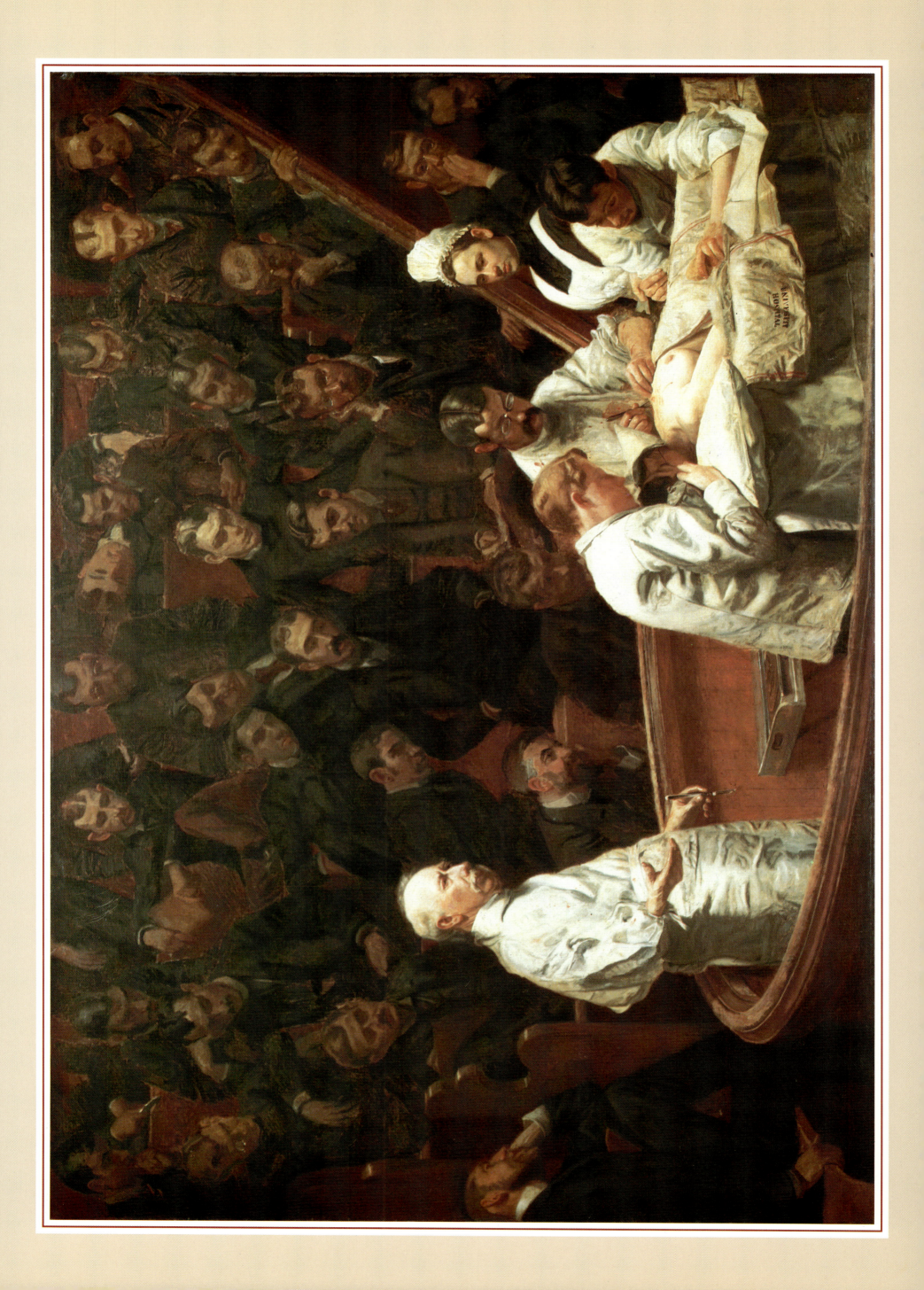

THE AGNEW CLINIC

Thomas Eakins
1898

Canvas, 331.5 × 179.1 cm
University of Pennsylvania School of Medicine, Philadelphia, Pennsylvania

SCIENCE that knowledge attained through study, practice, and research that would provide the basis for the eradication of rampant disease and illness. For many years medieval methods were used in diagnosis, and treatments generally were not scientifically based. Emetics, purgatives, and bleeding were the chief methods employed in the care of the sick. Brandy and whiskey became favorite remedies for febrile illnesses and continued to be so for a number of years. By the middle of the nineteenth century, however, the contributions to scientific knowledge made by Pasteur, Lister, Koch, and others began the modern era of medicine and surgery. The science of bacteriology provided the foundation. The introduction of ether and chloroform as general anesthetics facilitated surgical practice. Needed reforms began to occur. These advances altered the course of medical history to the point that concepts of illness, treatments, and hygienic practices at the end of the century bore little resemblance to what they had been in the beginning. It was not until events such as the Crimean and Civil wars, however, that the first major reforms occurred in nursing. These wars brought the need for skilled nurses to the attention of government agencies. With the inception of the first formal nursing schools, patient care began to be strongly based on scientific principles and knowledge. Nursing thus was regarded as both an art and a science, with grave consideration given to the use of the scientific method in the rendering of care. The "science of nursing" has evolved from an infant stage in which nurses used scientific principles in patient care to a stage of commitment to the scientific method of collecting and interpreting data to generate new knowledge for the improvement of nursing care.

PLATE 14

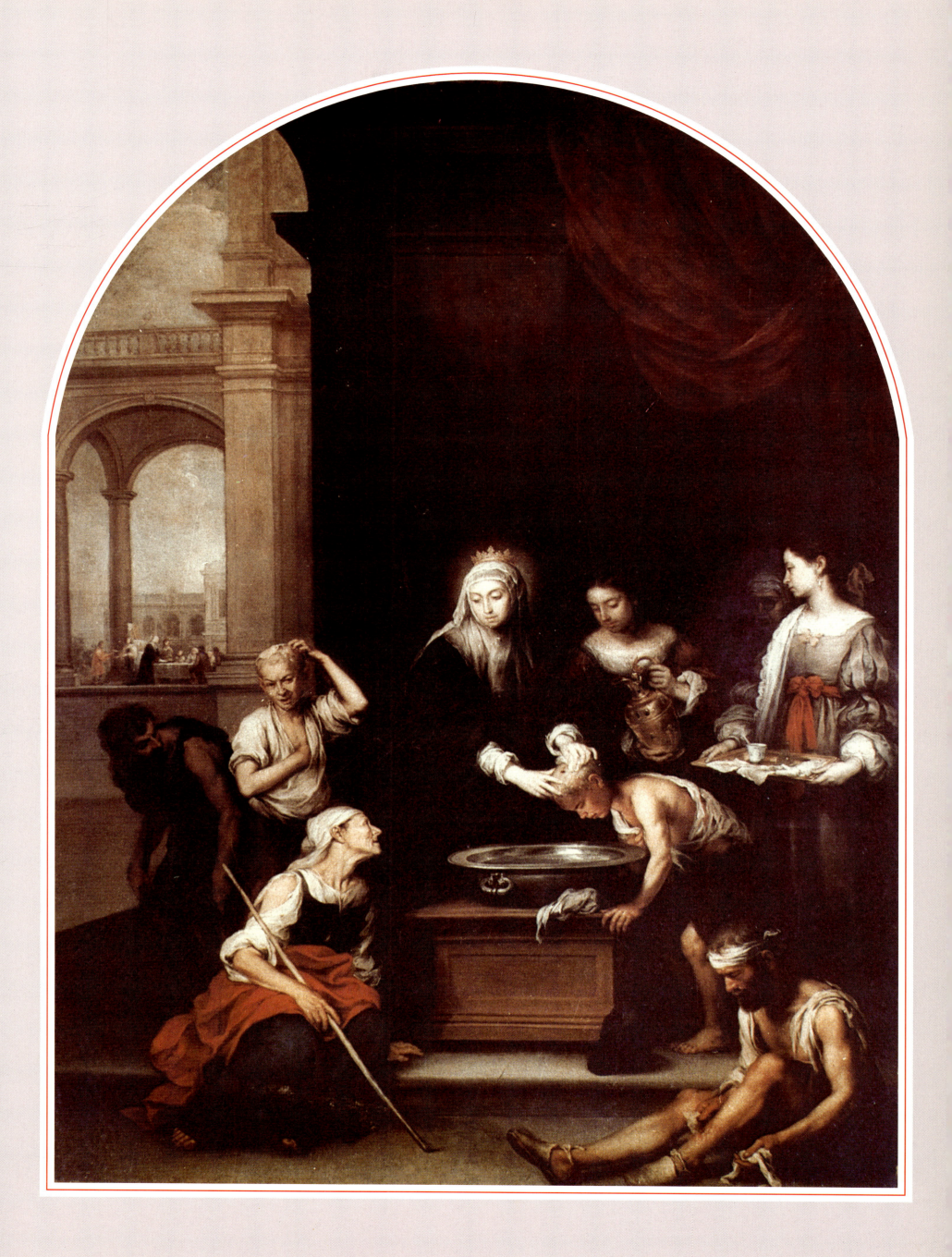

ST. ELIZABETH
BATHING PEOPLE AFFLICTED WITH RINGWORM

Bartolomé Esteban Murillo
c. 1670-1674

Canvas
Hospital de la Caridad
Sevilla, Spain

DEVOTION a way of life founded on religious beliefs and duties. Devotion was a key element in the roots of a movement toward the creation of religious orders of men and women. Their primary motivation of nursing the sick began to occur in the late Middle Ages. (Many of these groups eventually became housed in convents and monasteries and took vows of poverty, chastity, and obedience.) This was accompanied by a marked tendency toward the secularization and commercialization of nursing. One group, Tertiaries, or Third Orders, was founded for the laity of both sexes who wished to continue their ordinary lives in the world. The Tertiaries epitomized the ideals of St. Francis and practiced charity and devotion to God. Tertiaries lived almost the same life as the religious without being cloistered and were a powerful force for a number of years. Thus religion was carried into everyday life, and unselfish and useful service was rendered to humanity. Many famous nursing saints were enrolled in this order, including St. Elizabeth of Hungary. Her virtues have been set forth in prose, poetry, art, and music. Daily she distributed alms to the poor, fed the hungry, nursed the lepers, bathed newborns, and comforted their mothers with special tenderness. Hers was a life of extreme piety, asceticism, and austerity. Elizabeth was considered to be an excellent organizer, administrator, and nurse and is honored as the patron saint of nursing on November 19. Some consider her to be the forerunner of the visiting and public health nurses of the twentieth century. Her example of a distinctly humanitarian approach to the care of the sick and the poor illustrates the positive aspects of nursing's heritage from Christian teachings.

PLATE 15

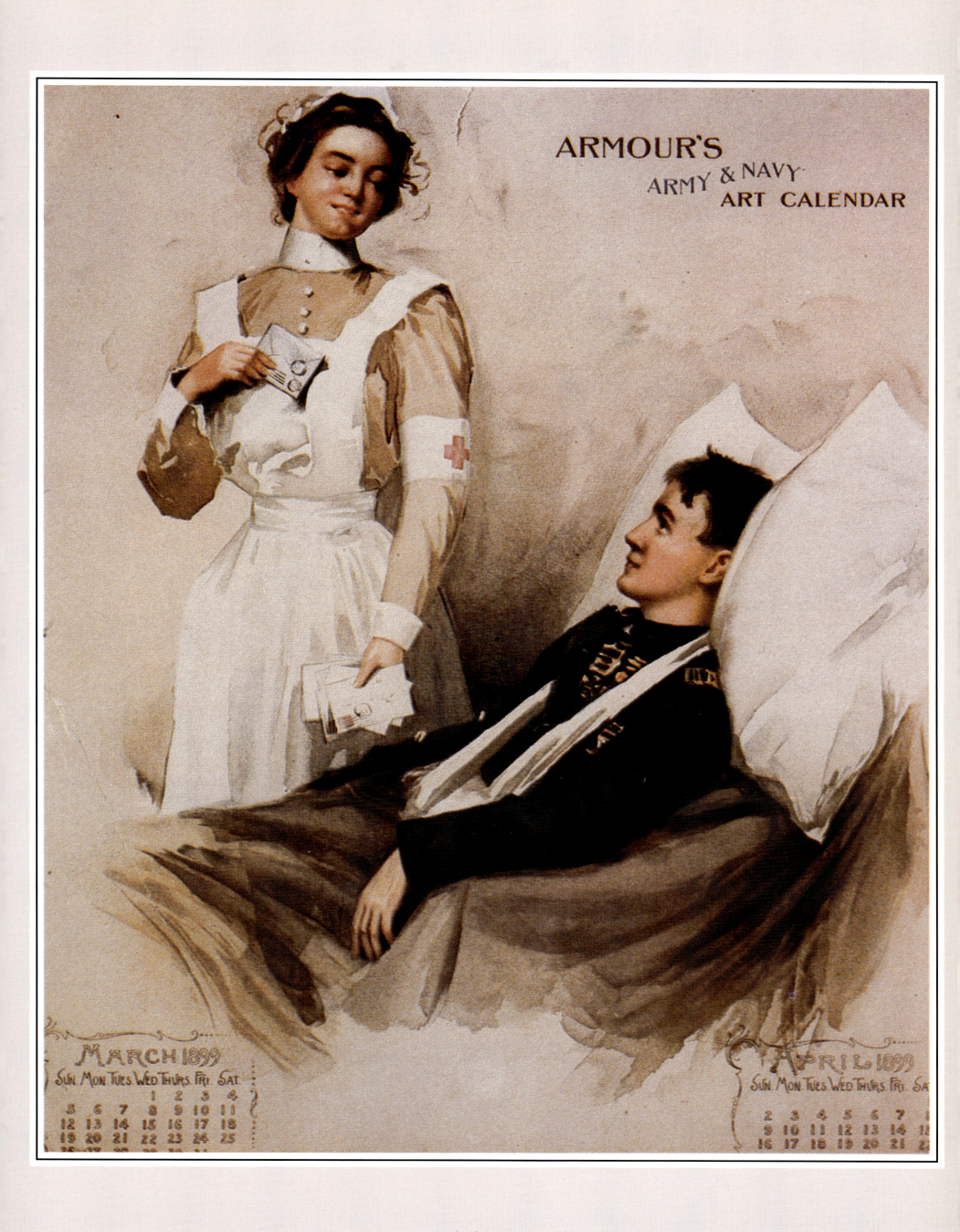

ARMOUR'S ARMY AND NAVY ART CALENDAR

1899

Donahue Collection

COURAGE the mental and moral strength, the firmness of mind and will that enabled nurses to face danger and extreme difficulties. A great deal of courage was exhibited by nurses during the Spanish-American War, the first war in which graduate nurses served with the armed forces. The war with Spain provided American nurses with their first experience in army nursing. Unfortunately, it also graphically illustrated deficiencies, such as the lack of a Red Cross nursing service, the need for an army nurse corps, and the lack of emergency reserves. American battle casualties were small during this war, but hastily constructed army camps were devastated by typhoid fever, malaria, dysentery, and food poisoning. Epidemic diseases caused ten times more deaths than did bullets. Nearly 1600 graduate nurses served. The first nurses appointed in May, 1898 were stationed in Army hospitals in the United States, Puerto Rico, Cuba, Hawaii, and the Philippine Islands. In addition, they served on the hospital ship, the *USS Relief.* Conditions of the worst type met the nurses, who often worked day and night with inadequate supplies and shelter. They eventually won respect and recognition, not only from the servicemen but also from the surgeons, who initially had been prejudiced against them. Thirteen nurses died while rendering nursing care during this war. The war experience definitely proved the superiority of the trained nurse over the untrained volunteer and led to the initiation of a permanent nurse corps. Immediately following the war, bills were proposed for the establishment of a nursing corps that would have the sanction and permanence of law. However, it was not until February 2, 1901 that a bill passed that established a permanent Nurse Corps as part of the Medical Department of the Army.

PLATE 16

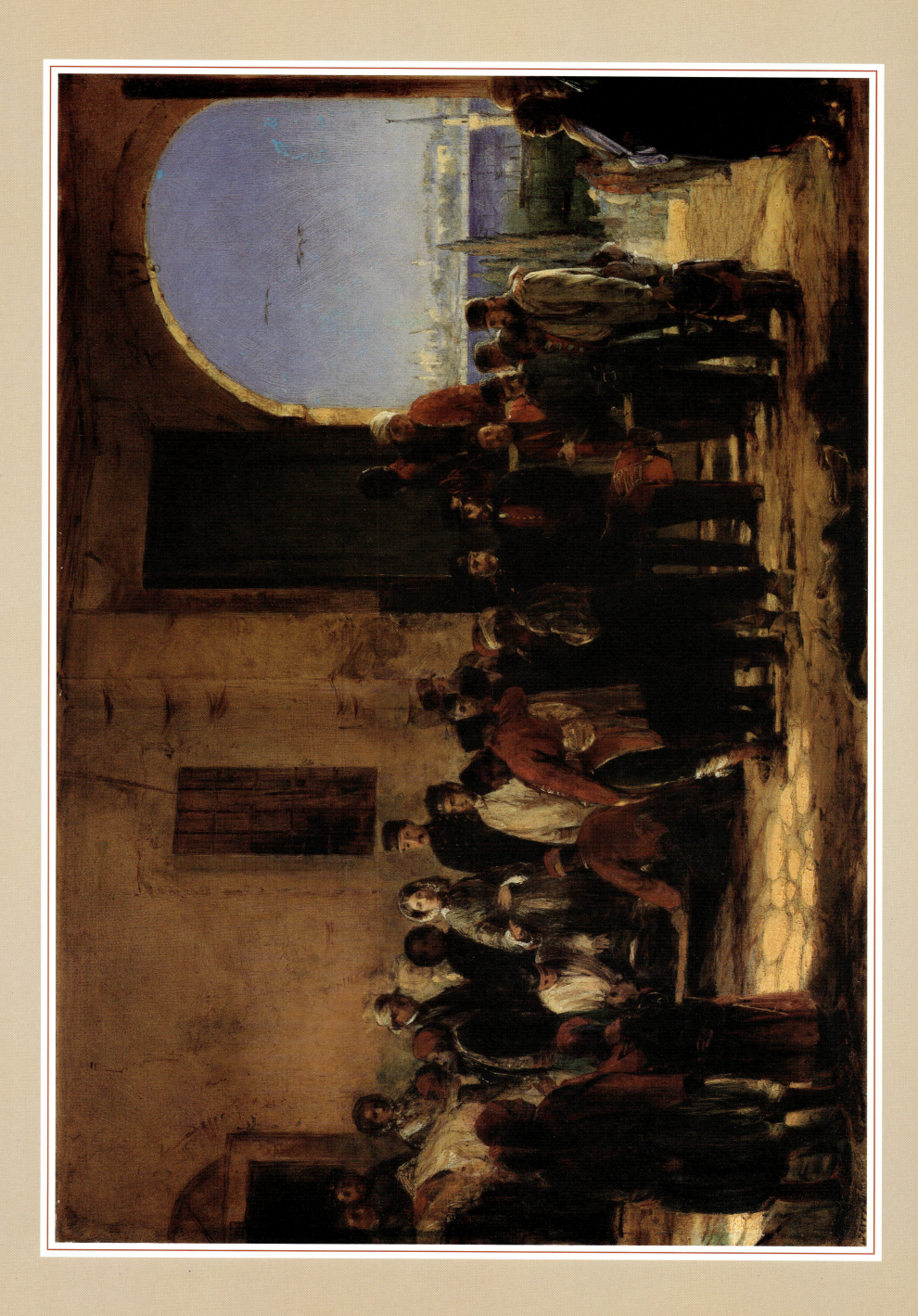

FLORENCE NIGHTINGALE
RECEIVING THE WOUNDED AT SCUTARI

Jerry Barratt
c. 1856

Canvas, 16 × 24 inches
National Portrait Gallery, London, England

INNOVATION a change or new idea for the improvement of conditions. Numerous nurses in history have introduced significant changes, but few can compare with Florence Nightingale in the areas of innovativeness and creativity. It is doubtful whether any woman's story has been repeated more often than that of Miss Nightingale. Yet existing accounts fall short in efforts to totally document her place in the sphere of social progress. Unquestionably, she was a significant individual in nursing's history and has been identified as the pioneer and founder of modern nursing as well as a reformer of hospitals. Florence Nightingale pursued a mission of service to humanity throughout her lifetime. Her achievements are especially impressive when viewed against the background of social restraints on women in Victorian England. Some still question which of her numerous contributions are the greatest. Certainly her transformation in the care of British soldiers at the Barrack Hospital in Scutari, her efforts to reform the military health care system, and her development of a solid nursing program built on sound professional standards are at the top of the list. Other of her endeavors are less well known, including her work in the area of statistical analysis. However, one need not review all the "causes" to which Florence Nightingale gave of herself in order to appreciate her roles as an innovator and a creative social force. She was a rare individual, a versatile genius who enacted many roles with distinction. She was a living memorial to a new type of thought that would forever influence the direction of nursing.

PLATE 17

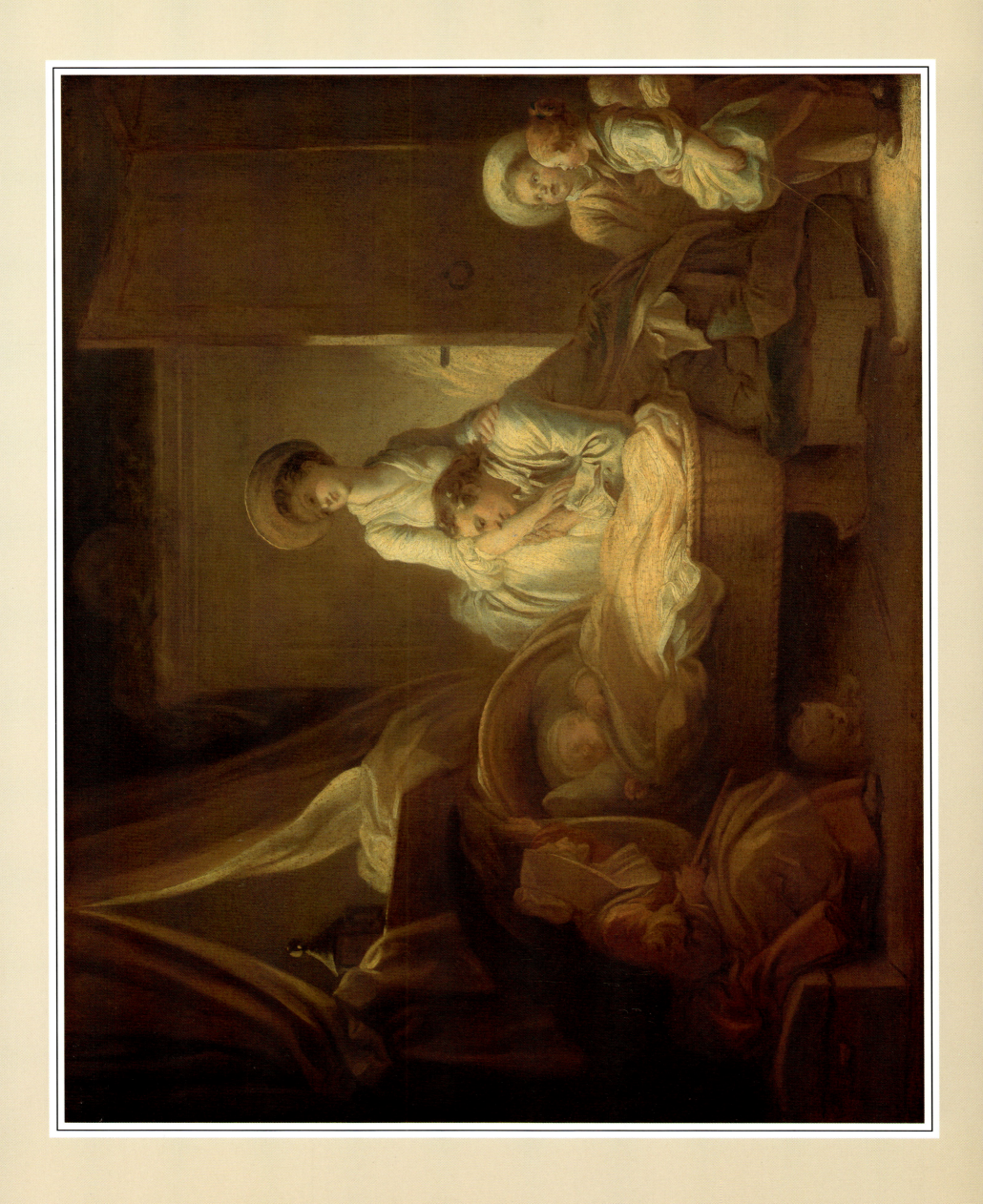

THE VISIT TO THE NURSERY

Jean-Honoré Fragonard
Before 1784

Canvas, 73.7 × 92.1 cm
National Gallery of Art, Washington, D.C.
Samuel H. Kress Collection, 1946

CONCERN a strong regard usually arising through a personal tie or relation-
ship. This tie or relationship was evident in primitive times as wives and
mothers provided care for their families. Eventually these women also cared
for those individuals afflicted by disease, age, injury, or other incapacitating
conditions. Thus early in its history, nursing can be distinguished as a form of
community service. This service was originally related to a strong instinct for
preservation and protection of the tribe and its members. Love and concern for
family and tribe later extended to neighbors and strangers. One rudimentary
way to assist with this effort was through the nursing of individuals who
became ill. As more sophisticated civilizations developed, the care of the sick
expanded to include concern for other human conditions. Methods for dealing
with problems such as poverty, prevention of disease, and any type of helpless-
ness added a social dimension to the nursing work. Those functions com-
monly associated with present-day social workers were incorporated into the
role of the nurse. Historically, the nurse and social worker were one. This
phenomenon continued until another group of workers was trained to handle
the problems associated with the social ills of society. Even then, as now, nurses
were still in a sense true social workers, constantly battling adverse social
conditions directly affecting the health and welfare of families and society. The
concept of nursing that has been evolving throughout the ages has not yet
reached its fullest maturity. It continues to grow and develop to include
widening spheres of nursing service and practice and expanding functions.
The element of concern is ever present.

PLATE 18

SISTER OF CHARITY

Robert Vickrey
1965

Tempera
Collection of I.B.M. Corporation, Armonk, New York

SERVICE a contribution to the welfare of others. The modern principles of visiting nursing and social service were sown during the sixteenth century, which saw renewed activity in nursing within the Catholic Church. Various religious orders devoted to this cause originated in this period; more than 100 female orders were founded specifically to do nursing. In fact, orders multiplied so rapidly and some had so little permanence that information about them is unavailable. Most prominent among these and one that has maintained importance until the present day is the Sisters of Charity, founded by St. Vincent de Paul. This order developed at a time when destitution and disease from continual wars were overcoming France. This society of ladies (Confrérie de la Charité/Dames de Charité) became the most widespread and best loved of all nursing orders. They took charge of hospitals, the poor, asylums, and parish work. They became widely known as visiting nurses, since they rendered both nursing care and spiritual consolation to the poor and the sick in their homes. This was the first society for organized aid in which a service was offered to as many people as possible. Sympathy for the poor was combined with a genius for organized reform and led to a system of social service, a method to help people help themselves. From this original society of eleven women numerous groups arose. Eventually a secular nursing order called Les Filles de Charité (Sisters of Charity) was founded with St. Louise de Marillac as its superior. Such was the modest and humble beginning of the now famous Sisters of Charity. They perhaps should be called Daughters of Charity, since St. Vincent always referred to them as "Filles."

PLATE 19

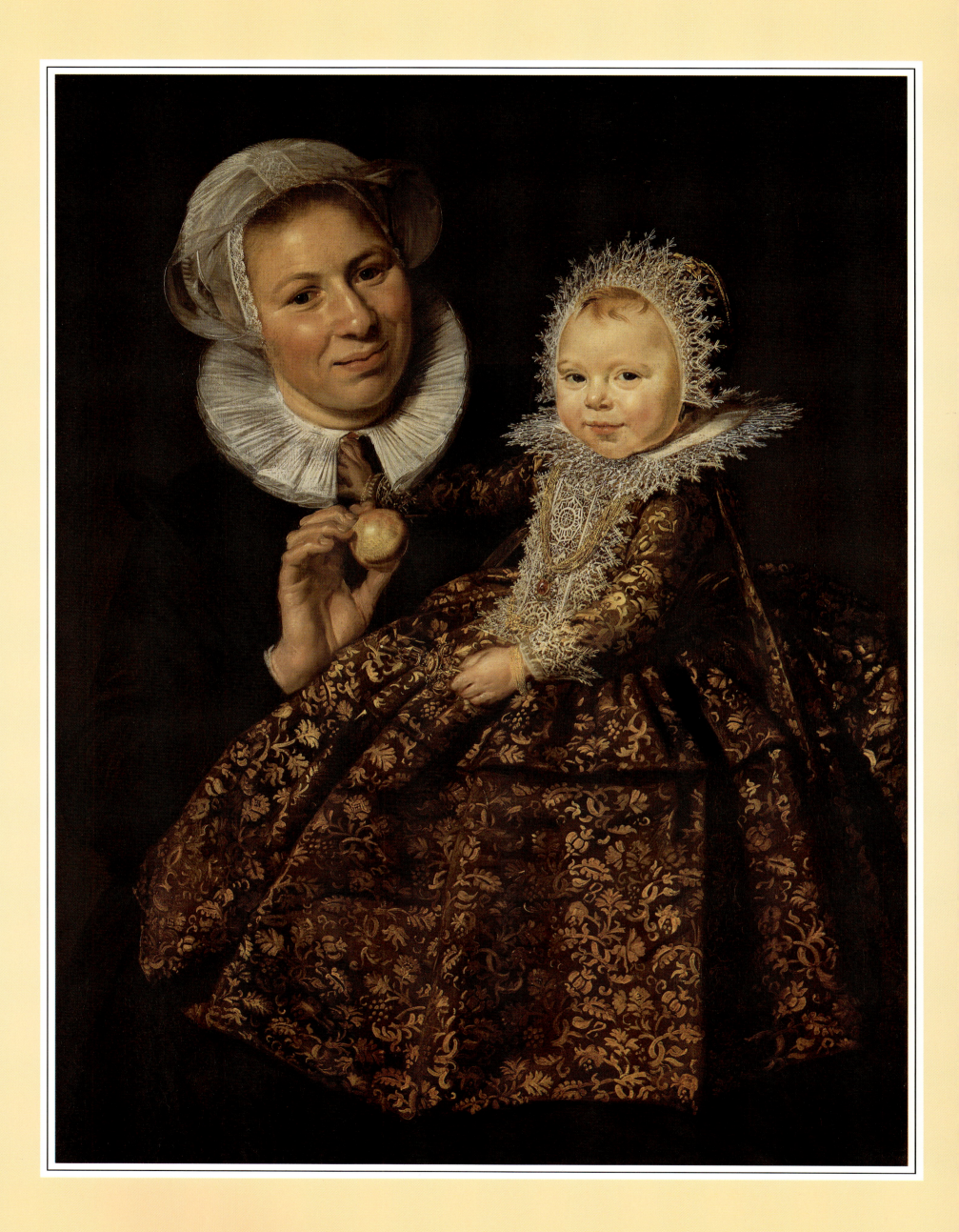

NURSE AND CHILD

Frans Hals
c. 1620

Berlin-Dahlem
Staatliche Museen Preussischer Kulturbesitz
Berlin, Federal Republic of Germany

COMMITMENT the obligation or emotional force related to persons, causes, or actions. Nursing's commitment to the health and well-being of humanity is deep-seated in a philosophy that each and every human being is entitled to safe, efficient, and competent care. Nursing's commitment to such care, however, strongly emphasizes lack of bias, that each individual shall receive care without regard for such things as race, creed, sex, social or economic status, personal attributes, or the nature of health problems. Consequently, throughout history, nurses have been involved in both popular and unpopular causes that have been concerned with health and social welfare. Particularly impressive has been nursing's response to the challenge to influence the provision of safe and adequate care for mothers and children. Numerous programs and pieces of social legislation specifically designed for the protection and promotion of health for mothers and children came out of the White House Conferences, the first of which was held in 1910. The key participants in this movement for social reform included a number of early nursing leaders who were involved in the social issues of the times, including women's suffrage, child labor laws, public health, and national defense. The high infant mortality rate, the exploitation of children through child labor, and the emerging understanding of the importance of childhood as a period of growth and development had led to an outcry for social reforms. Nurse involvement in the implementation of maternal and child health programs arising from the resulting social legislation was significant. Hundreds of nurses were employed to make home visits and supply health education and health screening of mothers and infants. Prenatal, infant, and preschool child health centers were established. A sound commitment to the protection of mothers and children became firmly entrenched in the discipline of nursing.

PLATE 20

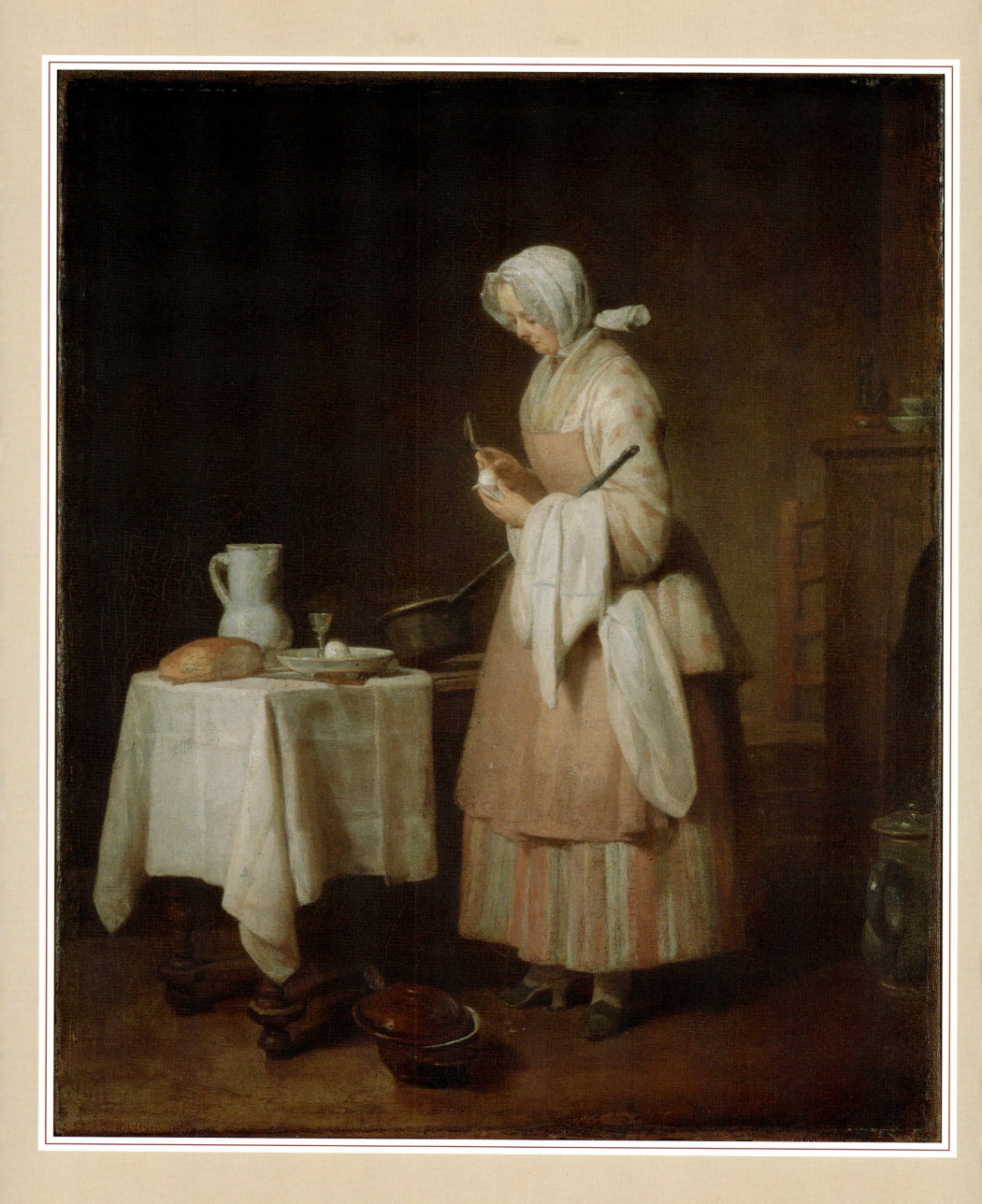

THE ATTENTIVE NURSE

Jean-Baptiste-Siméon Chardin
c. 1738

Canvas, 46.2 × 37 cm
National Gallery of Art, Washington, D.C.
Samuel H. Kress Collection, 1952

ATTENTION sympathetic consideration of the needs and wants of others. Nurses are attentive as they give special consideration to the needs, desires, and comfort of patients. The process of caring in which nurses engage involves attention to *all* aspects of human life and living, including death. This broad view developed in relation to the advent of Christianity; pure altruism as a motivation for nursing evolved into the care of the sick or disabled as a corporal work of mercy:

To feed the hungry.
To give water to the thirsty.
To clothe the naked.
To visit the imprisoned.
To shelter the homeless.
To care for the sick.
To bury the dead.

The corporal works of mercy encompassed basic human needs, recognized the needs of a variety of groups within the society, and reflected the desire for human compassion. A spiritual meaning became deeply attached to the care of the sick and the suffering. As a result, care of the sick was lifted to a higher plane; what had once been an occupation primarily of slaves or a necessary service of any household became a sacred vocation. This flowering of Christian idealism was to forever have a deep and significant impact on the practice of nursing. The positive aspects of nursing's heritage from the Christian teachings are evident. Yet this religious thought also handicapped progress in nursing. As nursing became closely identified with religion, strict discipline became a way of life. Those engaged in the nursing work were eventually trained in docility, passivity, humility, and total disregard for self. Unquestioning obedience to the decisions of others higher in rank was promulgated. An individual nurse's accountability, the personal responsibility for decision making in patient care, was thus bypassed and totally alien in nursing for many years to come.

PLATE 21

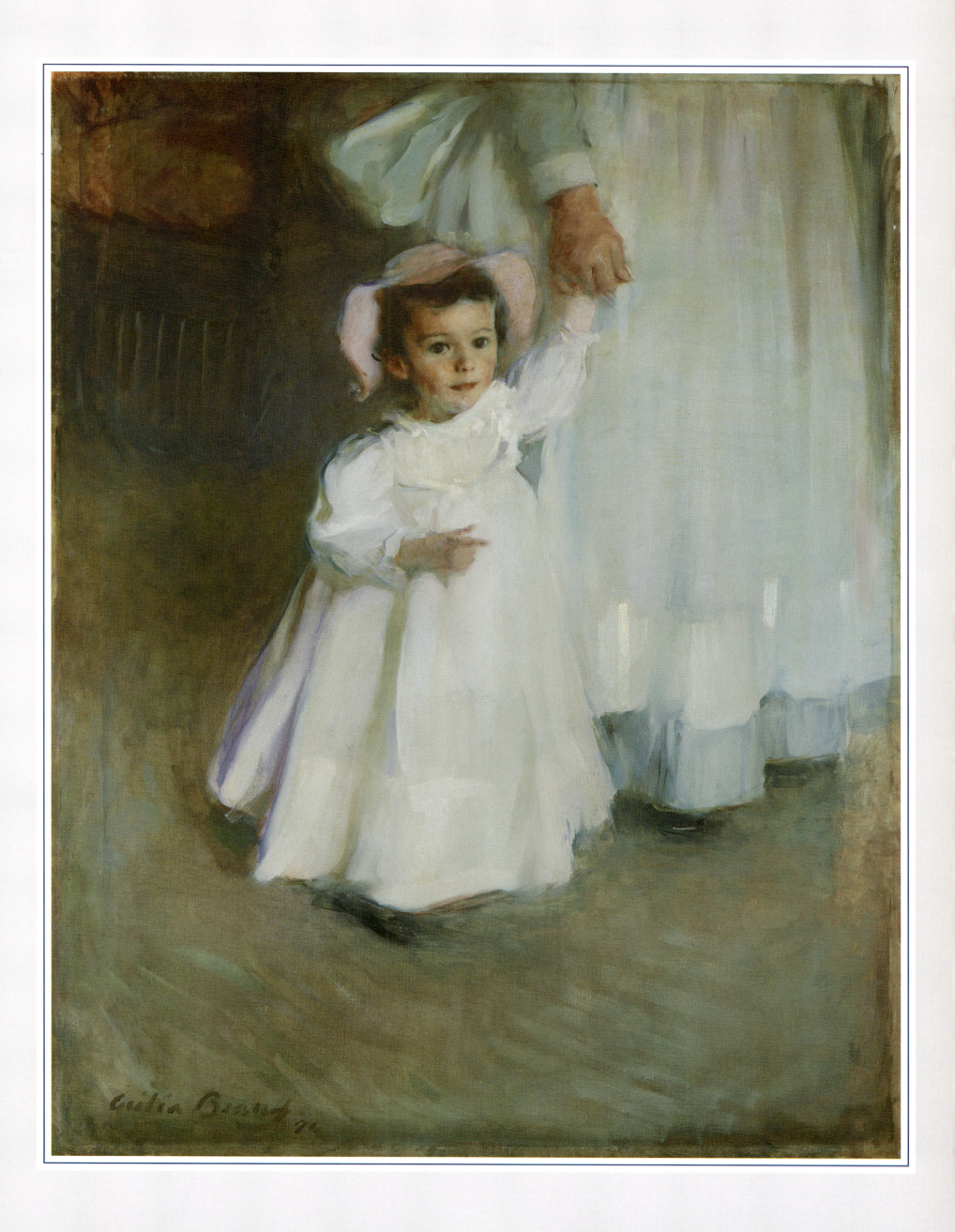

ERNESTA (Child with Nurse)

Cecilia Beaux
1894

Canvas, approximately 128.3 × 96.5 cm
The Metropolitan Museum of Art, New York
Maria DeWitt Jesup Fund, 1965

TRUST a word with many meanings but all conveying confidence in another or the commitment to one's care or keeping. Trust is an essential component of nursing, since nurses are entrusted with people's lives, often when they are at their most vulnerable. Such trust embraces the most delicate details of human beings, including physical as well as psychological intimacies. It also signifies reliance on the nurse to care for ill persons and significant others. Children have always been naturally entrusted to their biological mothers, but others slowly began to be trusted with their care and welfare. As the term "nurse" evolved to include the "wet nurse" as well as the "nursing mother," another dimension was added to its meaning: a woman who cares for and tends young children. Thus two kinds of helpers began to appear in some households—child nurses and sick nurses. The sick nurses were closely associated with the healing arts while the child nurses were associated with the teaching and training of children. Frequently, the two functions were combined and handled by one woman. The words "nursemaid" and "governess" thus emerged and became titles for the young girl or woman who functioned in the role of the child nurse. The care of children, who, for the most part, are consistently regarded as a priceless commodity, has always occupied an important position in nursing. Hundreds of nurses have been actively involved with various movements for social reform and the development of social agencies, including those related to mothers, infants, and children. All matters pertaining to the welfare of children and child life have continued to be of vital concern to nurses and nursing.

PLATE 22

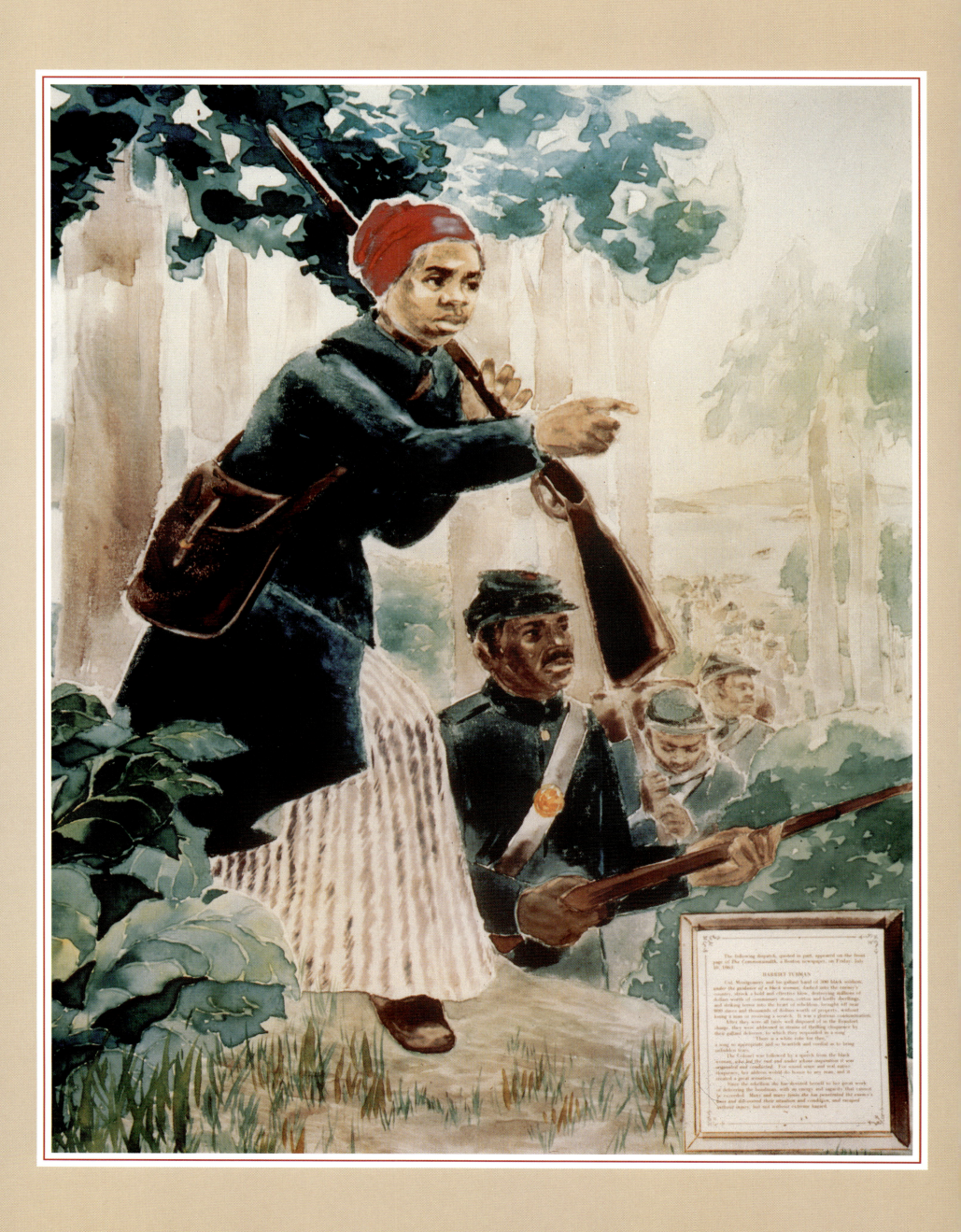

HARRIET TUBMAN

Joan Maynard
1977

Defense Audiovisual Agency, Washington, D.C.

DIGNITY a state of being that is desired by all human beings and that nurses constantly strive to provide or enhance for those in their care. Numerous events in history exemplify this quest for human rights and dignity. The Civil War is one such event that afforded numbers of men and women the opportunity to fight for such a cause. At the outbreak of the Civil War, there was still no group of trained nurses in the United States, but after the first battles the need for nurses became imperative. Many religious orders volunteered and offered their services. There were not, however, enough Sisters to care for the large number of sick and wounded. Hundreds of other women and men simply appeared in the camps and offered their services. Black women were among those who made significant contributions. Some were volunteers; others were employed under the general orders of the War Department. Several of them, including Harriet Tubman, competently cared for wounded soldiers in the Union Army. Harriet Tubman was called the "Moses of her people" and is credited with making nineteen trips to the South to assist over 300 slaves in their quest for freedom. She was an abolitionist who became active with the Underground Railroad movement after her own escape to the North. Her numerous exploits and denunciation of slavery gained her national recognition as a great humanitarian. At the onset of the Civil War, she turned her energies to the care of those who needed her ministrations. She was a highly respected, fearless, and courageous individual who not only served the sick and suffering but also fought for the freedom and dignity of her own race.

PLATE 23

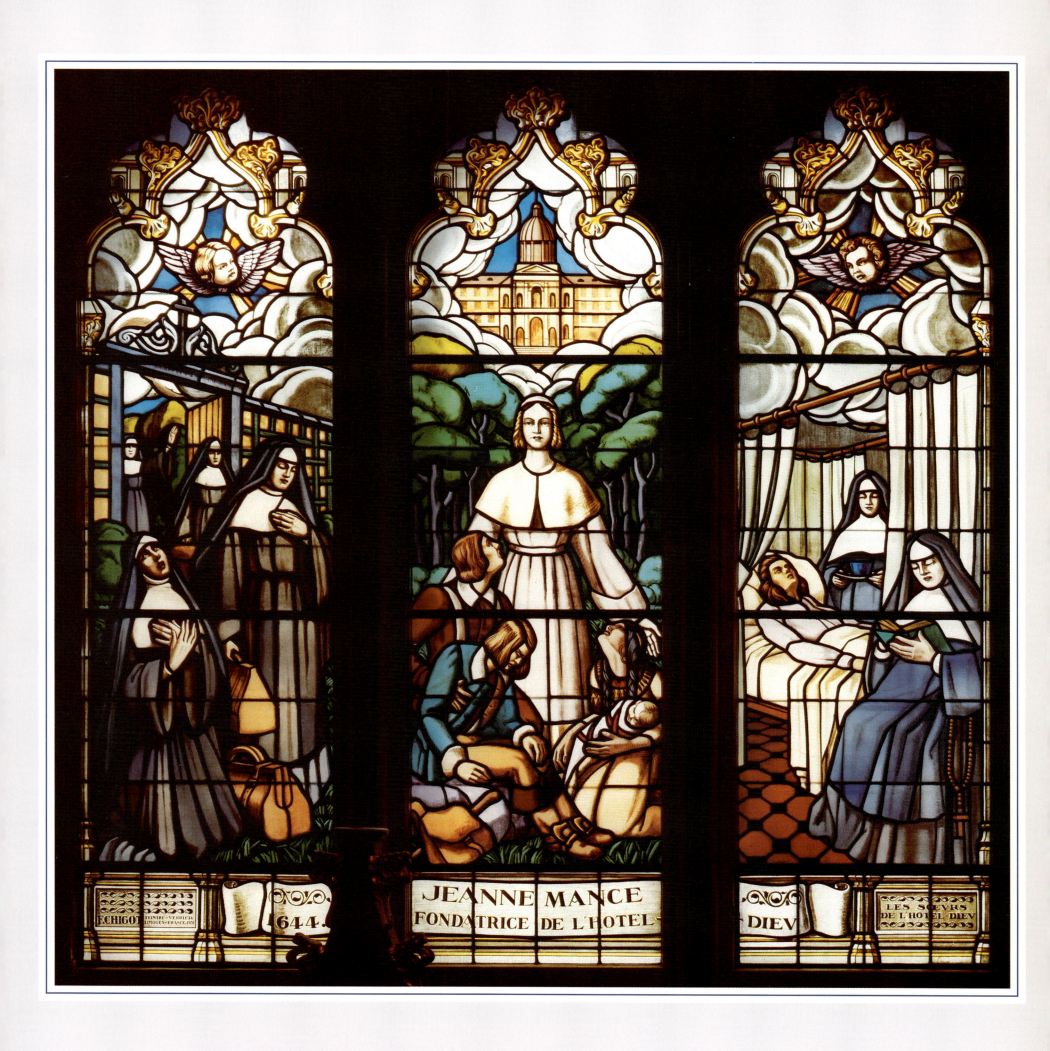

JEANNE MANCE
FONDATRICE DE L'HOTEL-DIEU

ECHIGO

644.

LES SŒURS
DE L'HOTEL-DIEU

JEANNE MANCE WINDOW

Stained Glass
The Notre-Dame Basilica
Montréal, Canada

PERSEVERANCE persistence in an undertaking in spite of opposition, interference, or counterinfluences. Throughout history many nurses have persevered in their efforts to provide care under difficult circumstances. One of these, Jeanne Mance, earned the reputation of being the "first lay nurse of Canada" and of North America as well. The original plans for Montreal included a school and a hospital, with the latter deemed to be an immediate necessity. The establishment of this hospital is the story of Jeanne Mance, a romantic figure in Canadian nursing and considered to the the founder of the Hôtel Dieu of Montreal as well as the co-founder of Montreal itself. She was the daughter of French parents and received instruction in nursing care while assisting the Ladies of Charity in 1638 during a severe epidemic. Upon her arrival in Canada, she entered the Augustinian cloister at Quebec, where she awaited the construction of the fort at Ville Marie, the future Montreal. She arrived there in 1642 and cared for the inhabitants of the settlement as they suffered through floods followed by warring Iroquois. In a tiny cottage hospital inside the fort, Jeanne Mance tended to arrow wounds, compounded her own medicines, treated chilblains and frostbite, practiced bloodletting, and cared for Indians as well as colonists. This tiny cottage eventually became the Hôtel Dieu staffed by hospital nuns from the Society of St. Joseph de la Flèche (Hospitallers of St. Joseph) with Mance as administrator. The first century of the hospital's existence was marked by a variety of misfortunes—Indian attacks, severe poverty, fire, earthquake, and famine. Jeanne Mance and the Sisters persevered and eventually experienced considerable prosperity and recognition for their good work.

PLATE 24

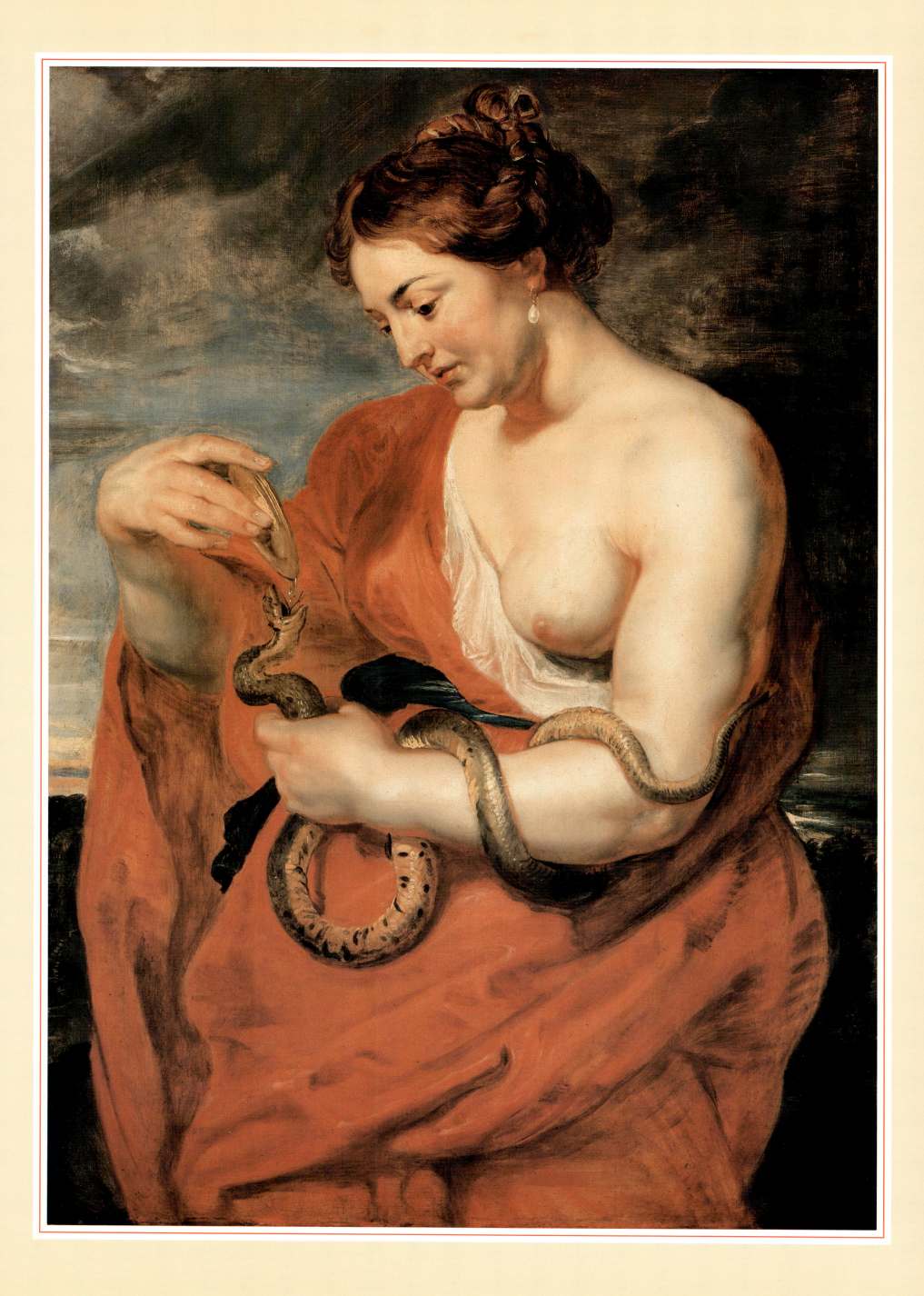

HYGEIA, GODDESS OF HEALTH

Peter Paul Rubens
c. 1615

Oil on wood panel, 106.7 × 74.3 cm
Detroit Institute of Arts, Detroit, Michigan
Gift of Mr. and Mrs. Henry Reicchold

HEALTH a state of being sound in body, mind, and spirit to which human beings have aspired. Emphasis on health can be traced to primitive people, who personified all that they saw in nature. They believed that the phenomena of nature were the greatest mysteries and developed mystic rites around the treatment and cure of illnesses and the preservation of health. These historic facts and the intimate and universal connection between religion and medicine led to a logical belief that was to permeate the majority of the ancient civilizations. Nature worship became the basic principle upon which the mythologies and religions of the ancient civilizations were founded. The belief in evil spirits as causes of disease progressed to a belief that disease was caused by a failure to do things that the gods wished or by some moral transgression. Legends and myths of deities who watched over health and had powers over life and death were composed and cultivated by nations. Traditions of worship and methods for requesting divine aid for the sick were established. Frequently temples were built to these gods and goddesses; they became temples for healing and, ultimately, sanctuaries for the sick. Asklepios (in Rome called Aesculapius) was the chief healer of Greek mythology. His wife and daughters, who included Hygeia, the "goddess of health," shared the work of health conservation. The myth of Asklepios became so complex that those temples built to him and famous for cures emerged as great social, intellectual, and health centers. Eventually, these "health resorts" were frequented not only by people who were ill but also by those who enjoyed the beauty and contentment of the surroundings and the brilliance of the cultural life and entertainment. The preservation of health has always been a major focus of nursing.

PLATE 25

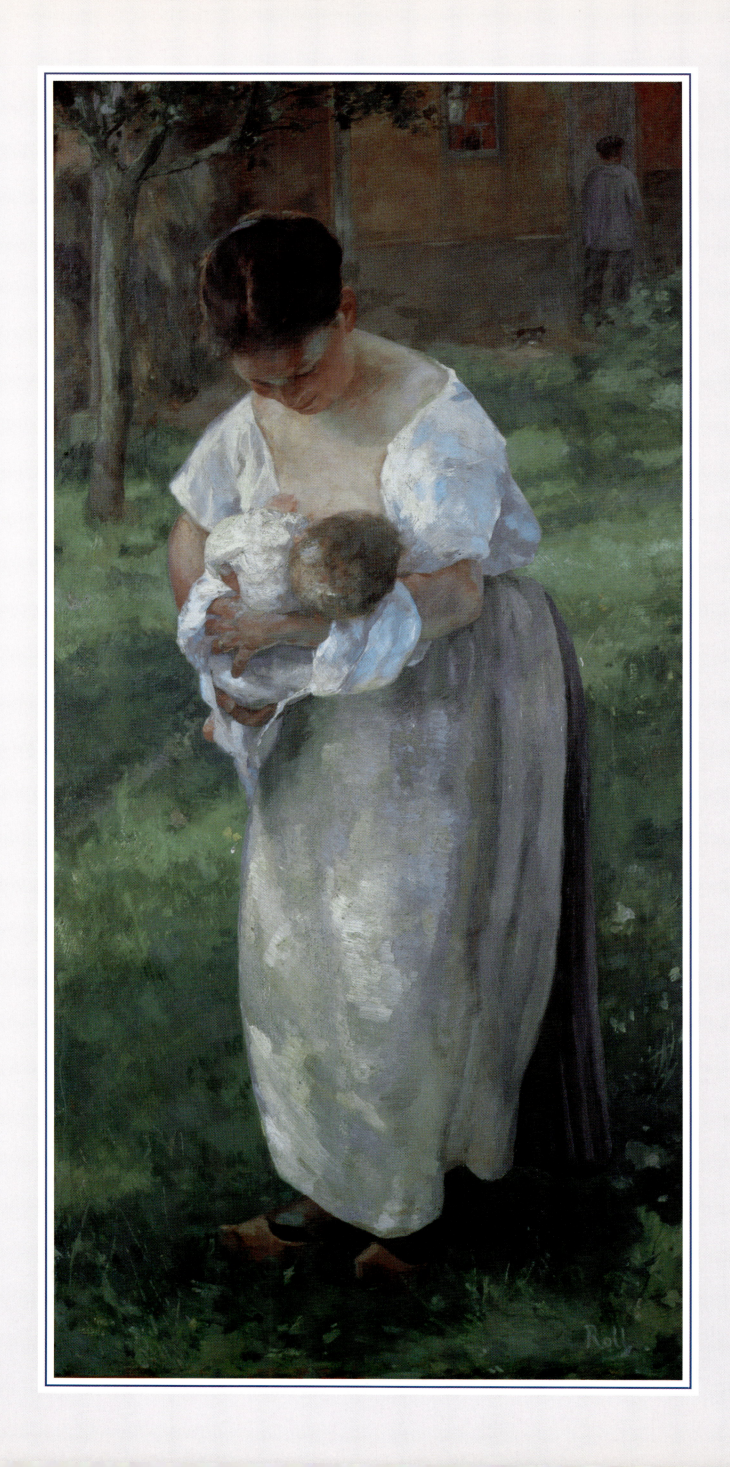

THE WET NURSE

Alfred Roll

The Bridgeman Art Library Ltd.
Musée des Beaux Arts, Lille, France

NURTURANCE affectionate care and attention through the maintenance, support, and promotion of growth; the provision of nourishment. Nursing has its origin in the mother-care of helpless infants and must have coexisted with this type of care from earliest times. The word *nursing* is derived from the Latin *nutrire,* "to nourish." The word *nurse* also has its roots in Latin in the noun *nutrix,* which means "nursing mother." Frequently this referred to a woman who suckled a child who was not her own, that is, a wet nurse. Eventually the term *nutrix* was used to identify a female who nourished, which provided a broader yet still gender-related definition. This nourishing or maternal instinct perpetuated the female image of nursing, that nursing could be done only by women. In addition, nursing began in the home as a natural part of a woman's domestic duties as she fulfilled her obligations to her family. Thus, the nurse as a loving mother who intuitively comforts and renders care continues to be a popular image. The parental instinct more accurately describes this strong motive and is present in both sexes of all races and within different age-groups. It is generally thought, however, that women possess a greater degree of this instinct because of greater experiences in parental activities. Yet the timeless spirit of nursing contains no sexual boundaries. Human beings of both sexes have a natural tendency to respond to helplessness or to a threat to life from disease or injury. Men and women have functioned as nurses throughout various periods in history.

PLATE 26

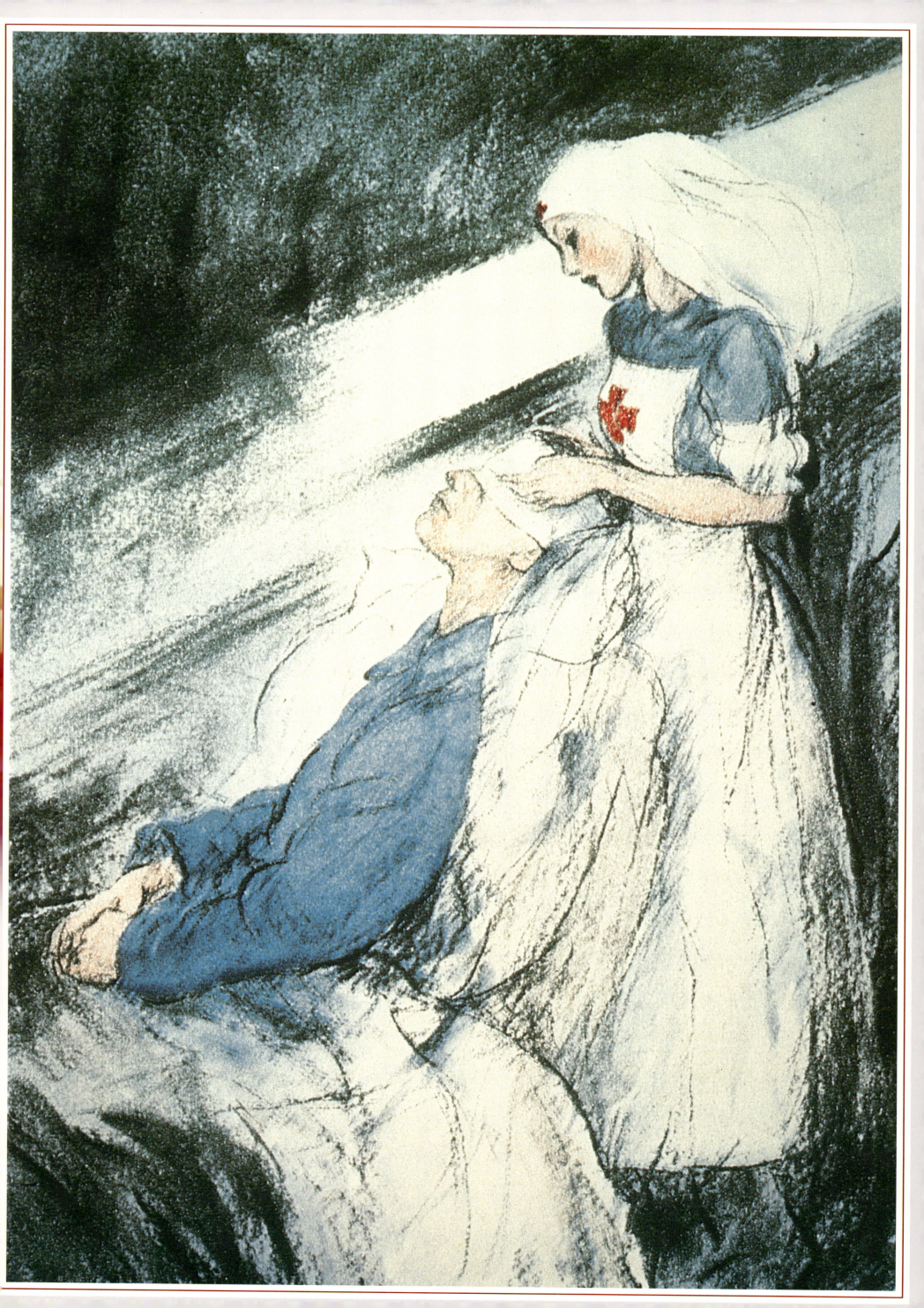

THE RED CROSS OF COMFORT

John Morton-Sale
1939

Photogravure of the original painting
Courtesy of the artist

COMFORT one simple word. Yet this concept helps to create a world of nursing that encompasses the integration of concern for the spiritual, emotional, and physical aspects of patient care. It is through comfort and comfort measures that nurses provide strength, hope, solace, support, encouragement, and assistance to individuals, groups, and communities as they experience a multitude of life circumstances. Throughout the history of nursing, nurses have acted to ease the grief or suffering of those they serve, have acted in the role of comforter. Red Cross nurses have consistently exemplified this commitment to the relief of suffering both in time of war and in time of peace. The original charter of the International Red Cross stated that the organization was dedicated "to continue and carry on a system of national and international relief in time of peace and to apply the same in mitigating the sufferings caused by pestilence, famine, fire, floods, and other national calamities, and to devise and carry measure for preventing the same." A single determined emblem, a red cross on a white background, governs and protects those wounded in war, the supplies needed for their care, and the personnel attending the wounded. This symbol, however, is also indicative of nurses' involvement in a permanent national and international relief society. As such, humanitarian services are rendered as individuals and societies face emergencies and disasters such as floods, fires, tornadoes, mine cave-ins, epidemics, and other devastating catastrophes.

PLATE 27

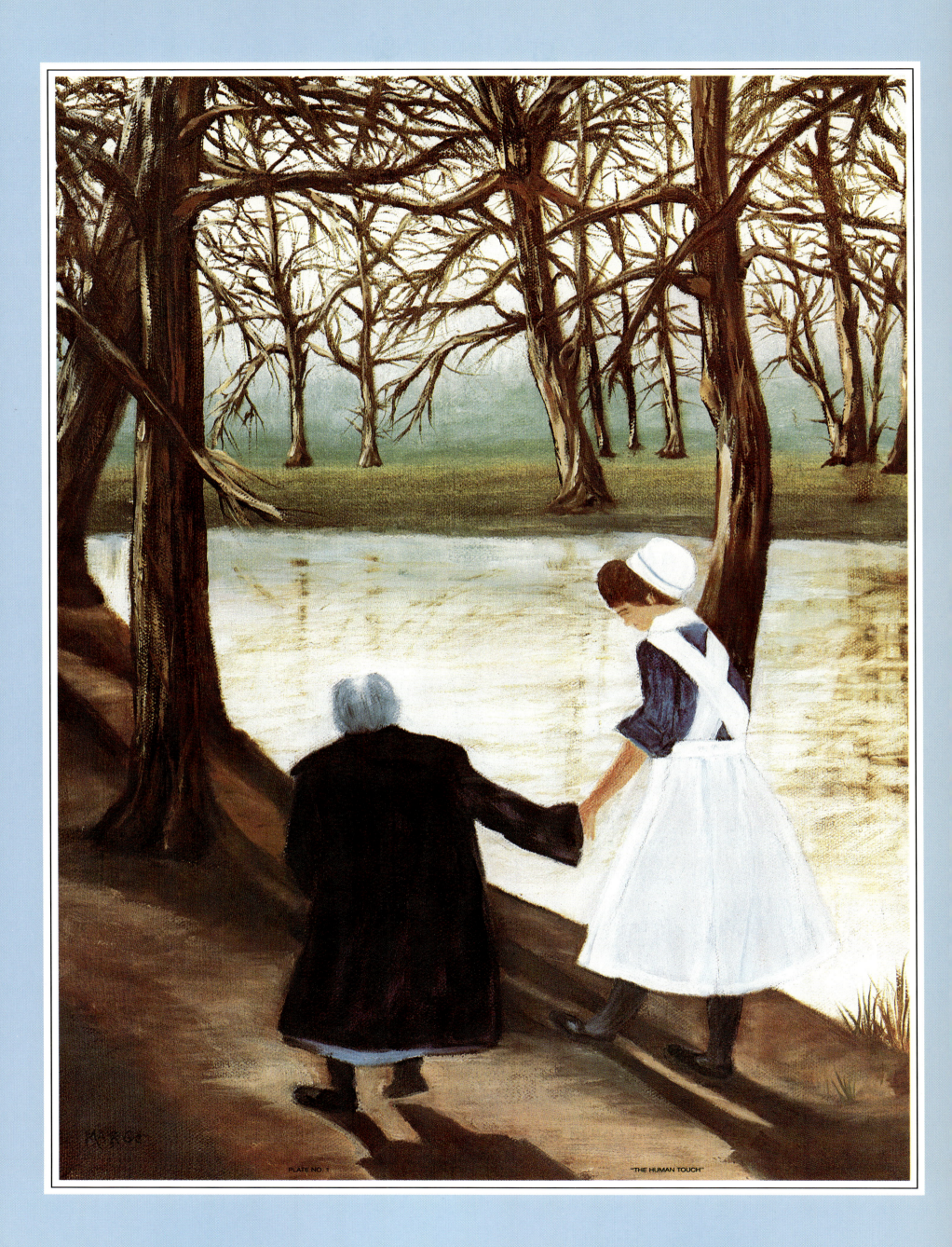

PLATE NO. 1 "THE HUMAN TOUCH"

THE HUMAN TOUCH

Marjorie Glaser Bindner
1980

12 × 16 inch oil painting on canvas
Courtesy of the artist

TOUCH that special sense that is used by nurses as they render care. Touch is
an integral part of nursing, yet its meaning can be difficult to articulate. It is
used in a variety of ways to comfort, soothe, feel, appreciate, understand,
respect, and heal. Its use as a vehicle for communication, however, remains
unsurpassed, particularly in the discipline of nursing. No matter whether a
patient is conscious or unconscious, young or old, ambulatory or immobile,
black or white, literate or illiterate, nurses are able to effectively communicate
through touch. In a simple touch, more love and understanding can be con-
veyed than could have been communicated with any amount of words. This
has become extremely important as society and patients increasingly confront
a world of high technology. The challenge for nurses has thus become the
creation of a viable approach to balance technology with touch. Touch, as an
act of understanding, can give energy, love, respect, and dignity to those who
are vulnerable and whose lives are entrusted to nurses. It is also an intimate act
that allows nurses to rise above social taboos. Nurses touch the private parts of
their patients' bodies, which enables a formation of trust and closeness that can
almost be spiritual. Physical touch not only provides a mechanism for the
assessment of patient status and the provision of nursing acts such as bathing
but also conveys the emotional element of caring so crucial to patient well-
being. Touch truly unites the head, the heart, and the hands of the nurse to
provide the strong foundation for modern-day nursing.

PLATE 28

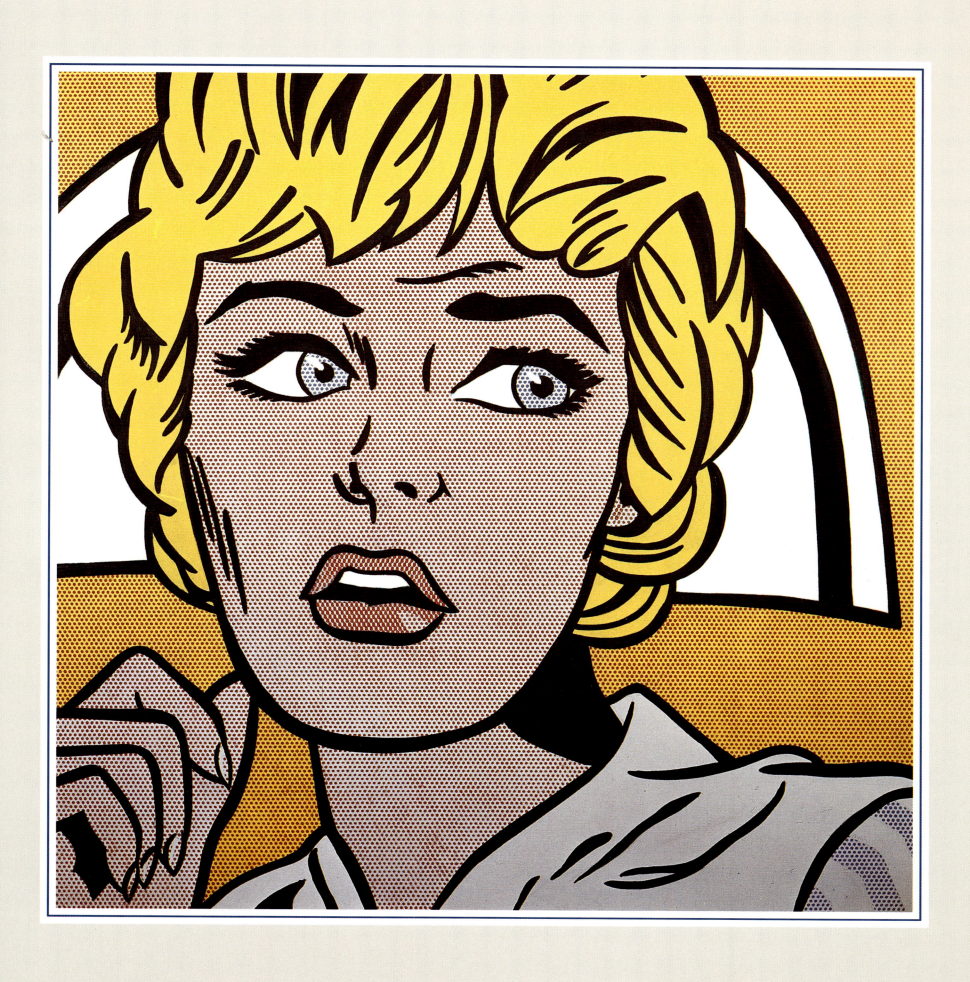

THE NURSE

Roy Lichtenstein
1964

Canvas
Hessisches Landesmuseum Darmstadt
Federal Republic of Germany
Collection of Karl Stroher

PROFESSIONALISM the conduct, aims, or qualities that characterize a profession or professional person. The quest for ethical standards, specialized knowledge, and intensive academic preparation that are marks of a profession are now within nursing's reach and consistent with nursing practice that is constantly expanding and extending. Numerous changes have occurred in nursing throughout the course of the twentieth century. The advent of new drugs, new techniques, and new technologies has placed new responsibilities on nurses and has mandated radical changes in nursing care. The age of specialization in health care has also mandated changes in nursing practice. All types of specialty areas—coronary care units, surgical intensive care units, medical intensive care units, burn units, dialysis units, oncology units—were developed in hospitals and necessitated the changing of nursing roles. The role of the nurse is thus constantly changing, and nursing practice is becoming more sophisticated. New theories, techniques, skills, and tools are being used in practice to meet the current needs of a society that is highly technological, complex, and dynamic. All of these events have led to the development of revised or new curricula in basic educational programs and the establishment of new programs in graduate education to prepare nurses to acquire the knowledge, skills, and responsibilities consistent with health care reality. Nursing is finally beginning to be recognized as a legitimate science, but a continuing momentum is necessary to achieve this goal. Nurse scholars and practitioners of nursing have united efforts to assist with further identification of a knowledge base for nursing and to formulate a theory or theories to validate professional practice. The heritage of nursing is a rich one. Its history is a record of pioneering that reflects new advancements with each generation, that reflects a goal of professionalism in care. Truly, nursing is "a reflection of social reality"!

PLATE 29